DEVELOPMENTS IN RECENT SCULPTURE

DEVELOPMENTS

Whitney Museum of American Art

Richard Marshall

IN RECENT SCULPTURE

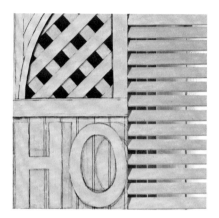 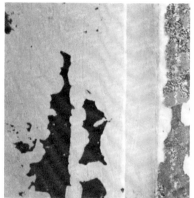 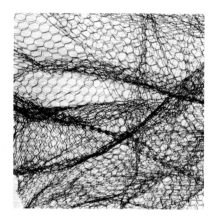

Lynda Benglis

Scott Burton

Donna Dennis

John Duff

Alan Saret

Dates of the Exhibition
July 22–September 27, 1981

Library of Congress Cataloging in Publication Data

Main entry under title:
Developments in recent sculpture.

 "Published in conjunction with an exhibition at the Whitney
Museum of American Art, July 22–September 27, 1981."
 Bibliography
 1. Sculpture, American—Exhibitions. 2. Sculpture,
Modern—20th century—United States—Exhibitions.
I. Marshall, Richard, 1947– II. Whitney Museum of
American Art.
NB212.D49 730'.973'07401471 81-11389
ISBN 0-87427-033-2 AACR2

Cover (clockwise from upper left):

Scott Burton. *Red Yellow Blue Cubes,* 1979–80. Lacquered
wood, 40½ x 30 x 30" (102.9 x 76.2 x 76.2 cm). Collection of
Barry Lowen.

Alan Saret. *Red and Blue Infinity Cluster Cloud,* 1980.
Lacquered wire and kymar, 31 x 21 x 21" (78.7 x 53.3 x 53.3
cm). Private collection.

John Duff. *White Wall Piece,* 1972. Fiberglass, paint, and
wood, 84 x 14 x 10" (213.4 x 35.6 x 25.4 cm). Whitney Museum
of American Art, New York; Gift of Hornick Industries,
Inc. 77.119

Donna Dennis. *Subway Station with Yellow and Blue,* 1974-76.
Acrylic and enamel on wood, masonite, and metal, with
fluorescent and incandescent lights, 79 x 49 x 65½" (200.7 x
124.4 x 166.4 cm). Neue Galerie—Sammlung Ludwig, Aachen,
West Germany.

Lynda Benglis, *Daphne,* 1978. Gold leaf, powdered pigment,
and gesso on plaster, cotton bunting, and chicken wire, 90 x
17 x 9" (228.6 x 43.2 x 22.9 cm). Private collection.

On title page, left to right, details of: Lynda Benglis, *Omega,*
1973; Scott Burton, *Granite Chairs,* 1978–81; Donna Dennis,
Hotel Pacifica, 1972; John Duff, *Large Oval II,* 1971; Alan Saret,
Green Wave of Air, 1968–69.

CONTENTS

FOREWORD

The Whitney Museum of American Art, founded by a sculptor, Gertrude Vanderbilt Whitney, has always been more closely identified with American sculpture and the work of living American artists than any other museum, a tradition we strive to maintain. The Whitney Museum Biennial Exhibitions are the best-known forums for review of contemporary art and form a part of the historical fabric of the Museum. However, it is often useful for a better understanding of current attitudes toward specific disciplines to take a closer look into the relatively short-term accomplishments of young artists of our times. This is a challenging experience both for the Museum and for the artist.

An historical review of an artist's work in the context of a museum makes a place for the artist in the history of art because the work has been acknowledged by an institution. To prevent any misunderstanding about the role of the institution in this endeavor, it must quickly be noted that it is the young artist who takes the real chance. To have one's work curatorially judged and assembled for all to see and assess, when there are still many productive years ahead which could be affected by the experience, takes courage and a resolute sense of one's artistic identity.

This exhibition reveals individual achievements and distinct stylistic approaches, and makes a collective statement about sculpture of the last decade. We believe the exhibition offers the public an opportunity to understand certain attitudes and ideas about contemporary sculpture and to gain insights into changing responses to the nature of sculpture.

Tom Armstrong
Director

"Developments in Recent Sculpture" focuses on five artists and traces the development of their independent approaches to sculpture. The exhibition seeks to assess the evolution of form and content in their work and, in the process, to gain insight into some aspects of American sculpture of the 1970s and early 1980s.

Despite the obvious stylistic differences between their work, the five artists presented here—Lynda Benglis, Scott Burton, Donna Dennis, John Duff, and Alan Saret—have certain artistic as well as biographical features in common. They are chronologically close in age—all were born between 1939 and 1944—and, while originally from various regions of the United States, they worked or continue to work in New York. Their sculpture, all of it produced within the last twelve years, thus assimilated and responded to the same political, social, economic, and artistic circumstances. Although not thematically related, their pieces are conceived and executed as portable object sculpture. It also becomes apparent that in their work, as in recent sculpture in general, there has been a shift away from the pure abstraction of Minimalist sculpture toward the reintroduction of content and allusion.

These sculptors approached artistic maturity at a time when Minimalist painting and sculpture prevailed. Unwilling to duplicate existing modes, they began to explore alternatives to and extensions of a Minimalist sensibility. Characteristic features of Minimalism—pure geometric form, process-oriented technique, attention to materials—are rethought and elaborated, introducing new procedures, new concerns and, as a result, expanding the possibilities of contemporary sculpture.

Minimalist sculpture championed the supremacy of primary shape and structure, seeking to minimize or eliminate any associative content. Recent sculpture has shown a renewed interest in injecting content, whether in the form of direct representation or implied reference. Post-Minimalist sculpture, seen in the work of the five artists exhibited here and in that of others who emerged in the 1970s, has made imagery and its direct or allusive meaning once again a significant part of sculpture. The artists in the current exhibition represent various stages and aspects of this trend. Each has consistently produced strong, challenging and engaging work during the approximately ten-year span of their careers. Each has grasped and maintained a distinctive vision, and explored a unique territory that tests, questions, and refines the definitions of sculpture.

The emphasis on process and materials which characterized the sculpture of the 1960s is retained in Lynda Benglis' work, but manipulated toward a different end. She continually stresses the strength and physical properties of the materials and the visibility of the process—pouring, layering, embellishing—while simultaneously juxtaposing opposites—hard/soft, solid/liquid, abstract/representational. Both the visible process and the juxtaposition of opposites encourage physical, emotional, and psychological responses. At the same time, her sculpture makes reference to identifiable objects—for example, knots and fans—and often provokes biomorphic and anthropomorphic associations. The wax paintings, begun in 1967–68, introduce a number of elements and concerns that are present in all of Benglis' later work: her interest in human scale and body reference; in layering, surface texture, and color; in wall-mounted objects that combine characteristics of painting and sculpture; and in physical, psychological, organic, and erotic allusions. The support for the wax paintings is a vertical lozenge shape that is approximately arm's length and as wide as one brushstroke. Onto this Benglis would apply stroke over stroke of pigmented beeswax, building up a deep, layered surface that splits horizontally in the center. The limitations of this scale led her to the latex and polyurethane foam works that were poured directly onto the floor or over temporary support structures. These works, such as *Quartered Meteor* (1969, cast 1975), were about painting and make direct acknowledgment to stained, color-field canvases. But they exhibit a desire to make painting more physical and dimensional, and to set up a tension between the process and the image. These works do not depict images, nor is the process of formation their subject matter. They do, however, evoke external references—to body functions, volcanic eruptions, oceanic phenomena—which speak for Benglis' efforts to elicit feelings and associations that are familiar and known. Some of the poured pieces of 1968–70 were later cast in various metals. Metals fascinated Benglis not only because of their permanence, but primarily because of their inherent attributes—energy, reflective surface, value as natural resources, and capability of being returned to a liquid state.

After a number of ambitious, environmental polyurethane foam pieces made for specific spaces throughout the United States, Benglis returned to the studio situation and, in 1971–72, produced *Totems*. She then began to tie these tall, thin tubes of plaster and gauze-coated wire into knot forms. Whereas the form of the poured works was partially dictated by the material, the knots exhibit intentional configurations that often read as specific anthropomorphic gestures. The first sparkle knots, such as *Valencia II* (1973) and *Two* (1973), are covered with paint and glitter in a way that calls attention to different planes of the knot but treats the three-dimensional surface as if it were flat. When she subsequently discovered techniques of spraying metal, she began a series of metalized knots. This type of coating appealed to her because the metal enhanced the sculptural

quality of the object, reinforced the tensile aspects of the form, and also accentuated the contradiction between organic and industrial references. A number of sprayed metals were used to explore various surface finishes, reflective qualities, and indirect associations: aluminum *(November, 1973–74)*; tin *(Whiskey, 1974)*; copper *(Bravo 2, 1975–76)*; and nickel *(North, South, East, West, 1976)*.

In a later group of works, Benglis returned to a vertical, unknotted form—like the wax paintings and totems—that is pinched in the center or at the ends, and layered with a thin skin of gold leaf. These pieces, too, make indirect references to organic imagery and body posture, recalling torsos, mermaids, animals, male and female attributes. *Daphne* (1978) exhibits a female reference (the upper, blue-painted fin form) and a male reference (the lower, truncated section with painted designs) in a totemic formation that both adheres to and extends from the supporting wall. The most recent group of works displays a gold-leaf surface over a fan-like format. Benglis' consistent attention to layering and surface skin—wax over masonite, latex over the floor, sprayed metal or gold leaf over plaster-soaked cloth over wire—and to the physical and perceived tension inherent in constructed forms—a configuration of accordion folds manipulated and frozen in a fixed moment—are combined in objects that have the ability to recall feelings, associations, and images.

John Duff's pieces in fiberglass, wood, and metal infuse formal, geometric configurations with a humanistic and personalized content. He reveals the materials and procedures used in the formation of a piece—such as fiberglass that mirrors the wood structure into which it was cast. The result is a lushness of texture and the impression of the artist's hand, which is not apparent in Minimalist sculpture. The color, scale, surface, and structural openness of Duff's work also encourage references to things outside the work—not specific or direct representations, but vague layers of associations and connotations.

Despite the stylistic disparity within Duff's production over the last decade, he has never ceased to explore line, edge, space, and surface. The early fiberglass works are about surface, edges, and planes that curve, cut, warp, and shift. Focus is on the edges and the tension that exists between the perception of the parts and the whole. Moreover, Duff is always attentive to manipulation of space. In the fiberglass pieces of 1970–74, the space considerations are more latent than in later works, and the pieces exhibit a primary concern with their topography. However, the hidden space defined in the *Duct Piece* (1970) or *White Wall Piece* (1972) is still accessible through the soft, translucent material that allows the eye to penetrate its surface. Attention shifts from the surface of the object, often displaying remnants of the casting process, to the perception of the contained space. These works also reflect the actual physical tension present in the molds from which they were formed. *Large Oval II* (1971) was formed from a standing sheet-metal ring that was stretched and

elongated by the placement of a central plank. The interior surfaces were then coated with resined fiberglass and the mold removed, leaving an oval bisected by an open shaft of space. *Curved Wedge* (1972–73), also a section of an oval, shows cuts in the curved rib which mirror the blocks of wood that held the wooden mold open in wedge formation. *Extended Polygon No. 3* and *Extended Triangle* (both of 1974) explore the consequences of a geometric form extruded. While obvious attention is given to the outside surface, the real subject is space passing through a form. A single, angled cut across the lower end of the piece reveals and acknowledges the form's shape, thickness and internal coloration.

In *Rietveld Column* (1975), a squared-spiral work in painted wood, the single and double structural elements of the previous pieces evolve into multiple combined modules. The welded steel works of 1978—geometric shapes formed by metal rods—also concern themselves with multiple facets, and elaborate on the function of edges and cuts first introduced in the fiberglass works. These pieces are primarily about the space that develops within the linear framework. The rods form a container or mold for space, similar to the fiberglass objects, and continue to stress the surface or skin around space. But unlike the fiberglass pieces, the steel-rod works rely on the viewer to perceptually fill in the spatial mass. *Architectural Object* (1978) superimposes two identical parts that result in a third, very different, whole. And although a perceived surface exists, the configuration formed by the two transposed linear wedges causes a visual warping of the internal space. The geometric and mathematical contradictions inherent in such a physical configuration thwart a logical reading and result in the perceptual formation of an amorphous and organic space. This space becomes the content of the rod pieces, and illustrates a midway development in Duff's evolution from the working of mechanistic qualities, as in the fiberglass sculpture, to organic qualities. It is these latter qualities which are further explored in the 1981 bronze pieces. The technique employed to form *A1* and *C1* (1981) is similar to the mold system used for the fiberglass works, and also corresponds to the structural purpose of the metal rods. The internal space of a rectangular wooden box is altered by the addition of a plaster build-up on the inside walls, which leaves a cylindrical space that constricts at each end. Duff takes a plaster cast of this space and then casts it in bronze. The result is an enigmatic object that records the impression of the artist's hand in the plaster, and is analogous to the impression and remnants of wood and paint visible in the fiberglass works. The bronze pieces testify to Duff's recurring concern with surface features, space defined by a skin or framework, and the passage of space through a form—but the original geometric characteristics are now subsumed in the piece itself. These works embody multiple, subliminal levels of procedure, meaning, and content, and advance Duff's ongoing desire to harmonize geometry, intuition, logic, contradiction, emotion, and humanity.

Alan Saret's metal, wire, and mesh sculptures are suspended from the ceiling, stand, or lean, and are rich with allusions to natural, cosmic, and mystical phenomena. The organic energy and the associations tied to the works triumph over their existence as material or process pieces. Although the initial response is to the configuration, color, and technique of assemblage, the slower and more lasting response is to the inherent substrata of organic allusions.

In Saret's wire-mesh network sculptures of the late 1960s, sheets of wire mesh are folded to achieve rigidity. These early pieces use commercially produced sheet wire in various manufactured states—gridded and hexagonal—that are available in rolls. Saret layered, creased, and folded the sheet wire, but allowed the physical properties of the material to dictate the final form. For this reason, Saret refers to the sculptures as "natural"—he does not control the shape but lets the character of the wire do so. In *Green Wave of Air* (1968–69) and *Untitled (Folding Glade)* (1969), both made from hexagonal wire netting, Saret's intent was to explore the limits of flexibility and rigidity in the material, and to make a sculpture that, like the netting, is more air than material. But the chicken wire and fencing wire also enhance referential readings because of their association with rural locales, farming, and ranching.

In *True Jungle: Canopy Forest* (1968) the structural principle is modular rather than continuous. The modules—painted pieces of galvanized wire—are attached to nails in the wall, achieving an arched, three-dimensional form. Every time the work is reinstalled, the nails are randomly placed, so that the resulting configuration differs for each installation. But the work's reliance on chance, process, and material is overshadowed by the visual allusion—strengthened by the descriptive title—to a kind of forest of horizontal strata ("canopies") that support a subsystem of animal and vegetable life.

During the early 1970s, Saret lived and traveled in India. Upon his return to the United States, he produced drawings and watercolors, but in 1975 began work on his most ambitious sculptural project to date. *Ghosthouse,* constructed at Artpark in Lewiston, New York, was a 20-foot-high flexible network sculpture that utilized Saret's training in architecture. Seeking alternative approaches to habitable structures, he constructed the piece of common steel fencing, folded to achieve strength and layered with shingles of polyethylene sheeting for rainproofing. The mesh character of the fencing, however, minimizes the mass of this large-scale steel construction, dispersing the structural matter and permeating the whole with light and air.

In the late 1970s, Saret began a new group of sculptures that culminated in the 1980 works presented here. They continue to explore the strength and flexibility of materials and the properties of texture and color. From commercially produced single-strand wire in a variety of metals and colors, Saret fashions atmospheric masses of twisted, tied, and tangled

wires according to systematized mathematical formulas. The seeming randomness in the assembly of *Copper Connection* (1980) or *Red and Blue Infinity Cluster Cloud* (1980) is thus deceptive; careful looking reveals the connecting nodes where two, three, or four strands of wire meet and branch off to other connecting nodes to form cubic or tetrahedral networks. The sculptures are ultimately reliant on the workings of gravity, the specific properties of different metal wires, and the mathematical, numerological, or architectural principles of their construction. The visual effect is more ethereal than material, and suggests associations and allusions—to galaxies, clouds, universes, energy currents, vines, vegetative growth and accumulation—that are external to the objects themselves.

The work of Burton and Dennis extends the development of specific reference in sculpture even further. Scott Burton's objects do not merely allude to furniture but *are* furniture. They explore the elusive duality of sculpture as furniture and furniture as sculpture, and concurrently question the role of sculpture that is functional and furniture that exists in an art context. Burton's work confounds the interplay of form and content by allowing pieces to play both roles, either alternately or simultaneously. While some pieces are abstracted but recognizable chairs or tables, others appear as non-referential configurations of Minimalistic, geometric shapes that only become furniture objects when their function as table, chair, pedestal, or storage unit becomes known.

Minimalism and Conceptualism had liberated art from the limitations of painting or sculpture, and also allowed the actual realization of a work to be carried out by others; Burton's first works were performance pieces that used found furniture as elements and props in tableau situations. His intense and growing appreciation of furniture heightened his desire to make a piece that did not too closely resemble an existing piece of furniture. This desire to transform or reconstitute known design elements resulted in the simple, stained-oak *Table I* (1973). A number of tables followed, conceived in 1974–75 and realized in 1977–78, that displayed an increased interest in design possibilities, form, color, and materials. *Mother-of-Pearl Table* (1975–78) and *Blue Granite Table* (1975–81) mark an evolution in Burton's interest in materials and required a more elaborate technology, new sources for materials and more fabricators to execute the works. In this sense, the pieces express Burton's desire to democratize the work, to mesh the decorative and fine arts and, in the Bauhaus tradition, to join art and craft.

In 1976–77, Burton's attention turned to the making of a chair of his own design. An earlier chair, dating from 1972, was a commercially produced Queen Anne-style seat that the artist had used in a performance piece, later painted with bronze paint, and then cast in bronze in 1975. The work prefaced Burton's involvement with the chair as an object, but still existed as a replica and maintained its link with the past. *Lawn Chair* (1977) moves

away from the replication of a found design to an invented variation of a type. A lawn chair is a familiar object, one that recalls various associations and memories, and that appealed to Burton because of its vernacular, common, and non-art origins. Burton has made his own distinct lawn chair by radically elongating the back legs, simplifying the supports and slats, and executing them singly and in pairs, in maple, pine, and laminated formica.

Granite Chairs (1978–81) are massive, severely geometricized, and assembled slabs of granite that recall a club-chair type of design. The contrast between the recollection of a soft, cushioned, indoor armchair and the hard, cold, granite—suggestive of an outdoor setting—is startling. This reversal of material and locale is also apparent in the paired *Rock Chairs* (1980)—roughly hewn, quarried masses of gneiss with sharply cut back and seat planes that appear incongruously comfortable indoors, and the traditionally woodsy outdoor lawn chairs that are placed indoors, faced in sleek, cool formica. Burton gives serious consideration to how the piece will affect the user/viewer—visually, physically, and socially. The works are scaled to human proportions and made to seem comfortable and appealing. The deliberate positioning of the chairs and consequent anthropomorphic references often become a metaphor for human interaction.

A second group of tables began with *Circle Square Triangle Table* (1978–80). It is composed of flat, cut shapes in hot-rolled steel, and introduces a more direct interest in geometry. *Pedestal Tables* (1980–81) translates into volumes what was done planarly in *Circle Square Triangle Table*. The *Pedestal Tables* and *Red Yellow Blue Cubes* (1979–80) signal a new approach to Burton's thinking about furniture—as an object whose function is to display or contain other objects. *Red Yellow Blue Cubes*, as the descriptive name implies, visually concerns itself with formal, sculptural issues—color, weight, size, balance, proportions. But it also makes a direct and humorous comment on the tension that exists in the furniture vs. sculpture dichotomy. To enhance the de Stijl-inspired sculptural physicality of this storage-cube unit, Burton masked the functionality of the piece by imitating the hinge seam on all edges of the cubes, so that it is not apparent that one side of each cube is a hinged door. *Ziggurat Table* (1980) continues the exploration of strict geometries and sculptural qualities. The table is composed of 400 pieces of joined mahogany and displays a concern with overall surface treatment. As much importance is awarded to the underside of the table as to the top, sides, and legs—a practice not ordinarily common in commercially produced furniture.

Ensembles of table and chair are explored in the *Child's Table and Chair* (1978) and *Table for Two* (1979). The child's set is trimmed in sweet shades of pink and blue with great attention to structural details, surfaces, and usability. Its scale, prettiness, and complexity are all intended to enhance the operational and functional possibilities for a young user. *Table for Two,*

an ensemble from a larger series of steel furniture, exhibits a stark simplification of form executed in cut and bent sheet steel. A suite of related pieces has been fabricated in three sets—lacquered steel, rusted and lacquered steel, and rusted corten steel. The repetition of forms and duality of function—stool or table, bench or table—marks Burton's first thinking about multiples and was conceived with the fabrication process in mind. This aspect of multiplicity, durability of materials, and broader availability is in keeping with his wish to extend his work to a larger public in an environmental context. The design of furniture allows Burton and the user/viewer to connect, combine, and perceive a number of artistic, social, and functional qualities in a unique sculptural object.

Donna Dennis' sculpture makes direct reference to familiar urban and rural architectural forms. The hotels, subway stations, and resort cabins are scaled down to approximate human height, and offer abbreviated and often abstracted depictions of known images. Although she is the most obvious in her use of sculpture as a vehicle for representational imagery and information, her pieces do not duplicate existing structures; rather, she presents imaginary types that isolate, combine, and invent architectural details and elements. These objects become charged with associative emotion and memory. As a result, they are not about architecture, but about forms that incorporate and elicit meaning.

In the early 1970s, Dennis decided to break with Minimalist and Conceptualist work and turn toward a more personal direction and subject matter. This shift coincided with her involvement in the feminist movement and her desire to make work that related to her life, but was at the same time concerned with color, craft, and surface texture. She began to be drawn to small nineteenth- and early twentieth-century buildings in New York, and found that these humble and overlooked structures had strong emotional connections for her. The first group of works, completed in 1972–73, are false-front hotels that incorporate painting and drawing in a three-dimensional format. The *Hotels* are actually painted facades, supported by braces and weighted with sandbags, and each features a doorway or entrance, too small and narrow to be entered, and mysterious internal lighting. The group of four *Hotels* was initially exhibited in a carefully planned environmental installation that included paper palm trees and taped bird sounds. This type of presentation, coupled with the theatrical structure of the hotel facades, encouraged and enhanced Dennis' attempt to allow the work to elicit personal recollections of real or imagined places and feelings.

Station Hotel (1973–74) also used the false-front construction, but introduced characteristics of New York City subway decoration. This piece and two subsequent subway works, *Subway Station with Lighted Interior* (1974) and *Subway Station with Yellow and Blue* (1974–76), all derive from Dennis' first-hand observation of architectural detail and material in subway stations. The pieces feature bare lightbulbs, trompe-l'oeil painted

tiles, gated openings, dark stairways, and paint drips that mimic numerous repaintings. They are menacing and forbidding shrines—yet they are familiar, engaging, and personalized relics of urban life. The next three works completed (each required approximately one year) change locales to more rural, domestic shelters of Florida (*Tourist Cabin*, 1976), Maine (*Tourist Cabin Porch*, 1976), and New Jersey (*Two Stories with Porch*, 1977–78). *Tourist Cabin (Pensacola)* is based on a Farm Services Administration photograph and presents a less hybridized architecture, yet still maintains strong emotional referents. The piece can be visually entered, but only partially—the screened-in porch and screen door hinder anything more than a strained look into the interior of the uninhabited cabin. *Tunnel Tower* (1979–80) is the latest, largest, and most complex work and returns to the city environment. It depicts an elevated structure topped by gridded scaffolding that supports a neon sign, and was inspired by a small structure that stands at the entrance to the Holland Tunnel in New York. The piece is minutely detailed and imposing, and recalls temples, subway stations, castles, and movie sets—and like all of Dennis' work, enlivens and enriches the meanings possible in sculpture.

Richard Marshall
Associate Curator, Exhibitions

Eat Meat, 1969 (cast 1975)
Bronze, 24 x 80 x 54″ (61 x 203.2 x 137.2cm)
Private collection

Quartered Meteor, 1969 (cast 1975)
Lead, 57½ x 65½ x 64¼″ (146.1 x 166.4 x 163.2cm)
Paula Cooper Gallery, New York

Wing, 1970 (cast 1975)
Aluminum, 67 x 59¼ x 60″ (170.2 x 150.5 x 152.4cm)
Paula Cooper Gallery, New York

Sparkle Totem I and II (Hoofers), 1971–72
Sparkle and pigment on plaster, cotton bunting, and
aluminum screen, 102 x 5½ x 4″ (259.1 x 14 x 10.2cm)
and 102 x 4½ x 3″ (259.1 x 11.4 x 7.6cm)
Paula Cooper Gallery, New York

Vogel, 1971
Pigmented beeswax and resin on masonite, 36 x 5 x 3″
(91.4 x 12.7 x 7.6cm)
Private collection

Wax Painting, 1971–75
Pigmented beeswax and resin on masonite, 36 x 5 x 3″
(91.4 x 12.7 x 7.6cm)
Margo Leavin Gallery, Los Angeles

Omega, 1973
Sparkle, enamel, and silver paint on plaster, cotton
bunting, and aluminum screen, 36 x 11 x 14½″
(91.4 x 27.9 x 36.8cm)
Private collection

Two, 1973
Sparkle, enamel, and silver paint on plaster, cotton
bunting, and aluminum screen, 31 x 12¼ x 16½″
(78.7 x 31.1 x 41.9cm)
The Solomon R. Guggenheim Museum, New York

Valencia II, 1973
Sparkle and enamel on plaster, cotton bunting, and
aluminum screen, 24 x 19 x 11″ (61 x 48.2 x 27.9cm)
Collection of Mr. and Mrs. Julian Ard

November, 1973–74
Aluminum and zinc on plaster, cheesecloth, and
aluminum screen, 18 x 22½ x 13″ (45.7 x 57.2 x 33cm)
Private collection

Victor, 1974
Tin, zinc, and steel on plaster, cotton bunting, and
aluminum screen, 66⅞ x 20½ x 13⅛″
(169.9 x 52.1 x 33.3cm)
The Museum of Modern Art, New York; Purchased
with the aid of funds from the National Endowment
for the Arts

Whiskey, 1974
Tin, zinc, and steel on plaster, cotton bunting, and
aluminum screen, 41 x 26 x 16″ (104.1 x 66 x 40.6cm)
Private collection

Bravo 2, 1975–76
Copper, steel, tin, and zinc on plaster, cotton bunting,
and aluminum screen, 52 x 21 x 30″
(132.1 x 53.3 x 76.2cm)
Whitney Museum of American Art, New York 81.13

North, South, East, West, 1976
Nickel, steel, tin, and zinc on plaster, cotton bunting,
and aluminum screen: *North*, 40 x 23 x 15½″ (101.6 x
58.4 x 39.4cm); *South*, 51 x 27 x 14″ (129.5 x 68.6 x
35.6cm); *East*, 37 x 29 x 19″ (94 x 73.7 x 48.3cm);
West, 60 x 24 x 17″ (152.4 x 61 x 43.2cm)
Hansen Fuller Goldeen Gallery, San Francisco

Mardi Gras (Lagniappe), 1977
Sparkle and gesso on plaster, cotton bunting, and
chicken wire, with laminated polypropylene and
polystyrene, 23 x 30 x 5″ (58.4 x 76.2 x 12.7cm)
Collection of Luiz M. S. Hafers

Meridian (Lagniappe), 1977
Sparkle and gesso on plaster, cotton bunting, and
chicken wire, with laminated polypropylene and
polystyrene, 24½ x 20 x 6″ (62.2 x 50.8 x 15.2cm)
Collection of William Hokin

Daphne, 1978
Gold leaf, powdered pigment, and gesso on plaster,
cotton bunting, and chicken wire, 90 x 17 x 9″
(228.6 x 43.2 x 22.9cm)
Private collection

Rhodos, 1978
Gold leaf and gesso on plaster, cotton bunting, and
chicken wire, 55½ x 26 x 11″ (141 x 66 x 27.9cm)
Texas Gallery, Houston

Gilget, 1980
Gold leaf and gesso on plaster and bronze screen,
36 x 36 x 3¼″ (91.4 x 91.4 x 8.3cm)
Private collection

Pushpa, 1980
Gold leaf and gesso on plaster and bronze screen,
24 x 24 x 11 (61 x 61 x 27.9cm)
Paula Cooper Gallery, New York

Shankh, 1980
Gold leaf and gesso on plaster and bronze screen,
41 x 16 x 13″ (104.4 x 40.6 x 33cm)
Paula Cooper Gallery, New York

LYNDA BENGLIS

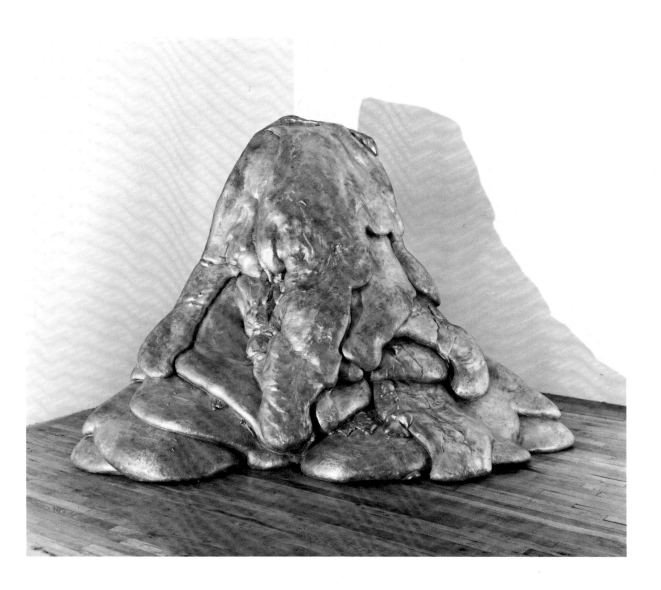

Quartered Meteor, 1969 (cast 1975). Lead, 57½ x 65½ x
64¼″ (146.1 x 166.4 x 163.2 cm). Paula Cooper Gallery,
New York.

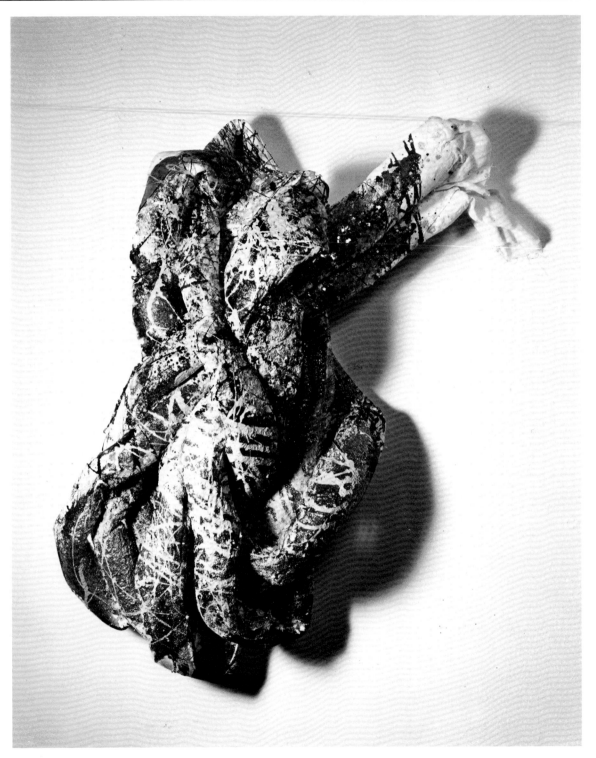

Omega, 1973. Sparkle, enamel, and silver paint on plaster, cotton bunting, and aluminum screen, 36 x 11 x 14½" (91.4 x 27.9 x 36.8 cm). Private collection.

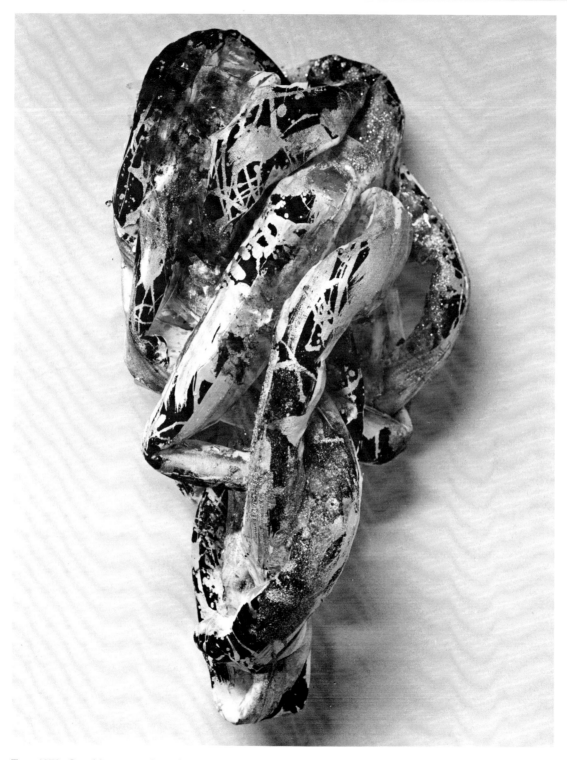

Two, 1973. Sparkle, enamel, and silver paint on plaster, cotton bunting, and aluminum screen, 31 x 12¼ x 16½" (78.7 x 31.1 x 41.9 cm). The Solomon R. Guggenheim Museum, New York.

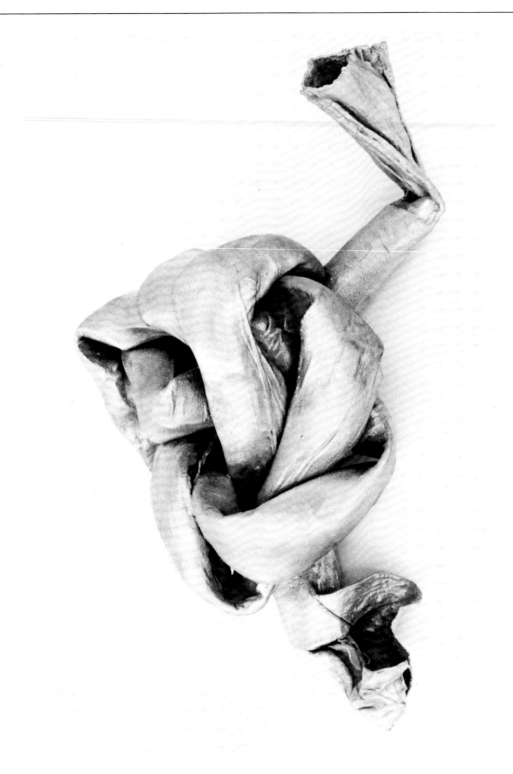

Whiskey, 1974. Tin, zinc, and steel on plaster, cotton
bunting, and aluminum screen, 41 x 26 x 16″ (104.1 x 66
x 40.6 cm). Private collection.

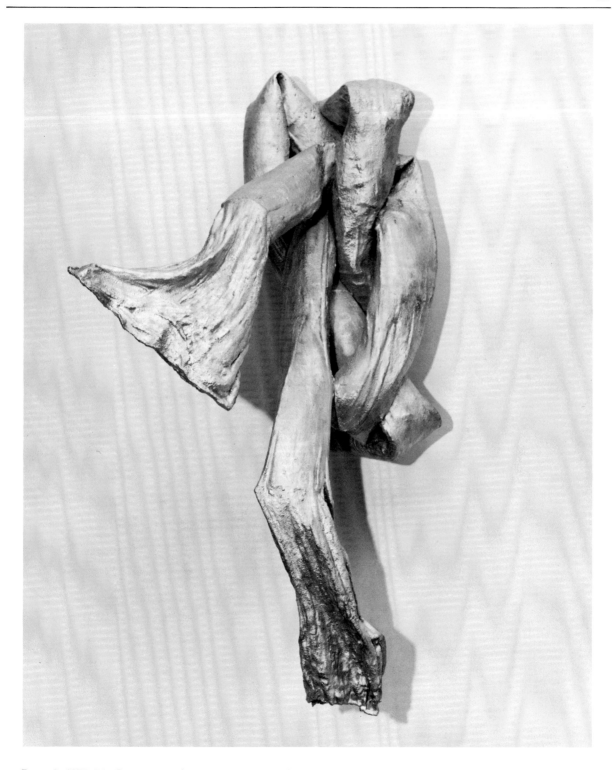

Bravo 2, 1975–76. Copper, steel, tin, and zinc on plaster, cotton
bunting, and aluminum screen, 52 x 21 x 30" (132.1 x 53.3 x 76.2 cm).
Whitney Museum of American Art, New York. 81.13

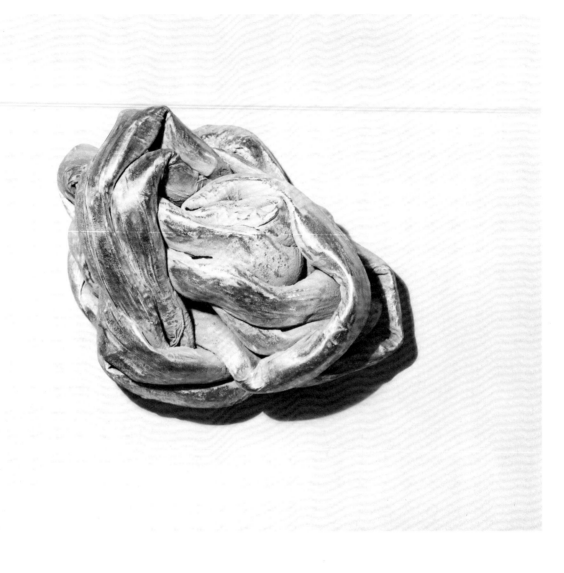

November, 1973–74. Aluminum and zinc on plaster, cheesecloth, and aluminum screen, 18 x 22½ x 13″ (45.7 x 57.2 x 33 cm). Private collection.

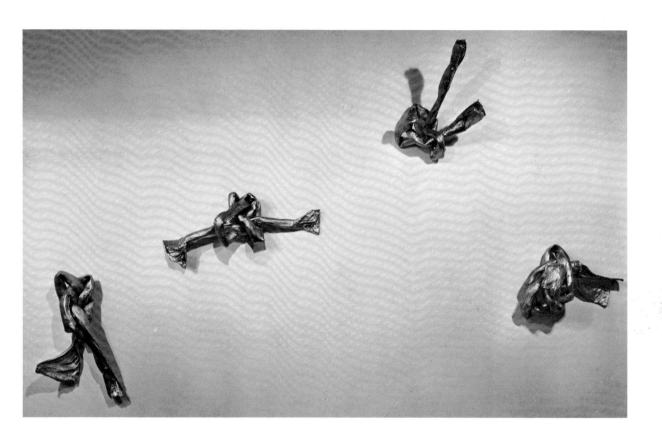

North, South, East, West, 1976. Nickel, steel, tin, and
zinc on plaster, cotton bunting, and aluminum screen:
North, 40 x 23 x 15½″ (101.6 x 58.4 x 39.4 cm); *South*,
51 x 27 x 14″ (129.5 x 68.6 x 35.6 cm); *East*, 37 x 29 x 19″
(94 x 73.7 x 48.3 cm); *West*, 60 x 24 x 17″ (152.4 x 61 x
43.2 cm). Hansen Fuller Goldeen Gallery, San Francisco.

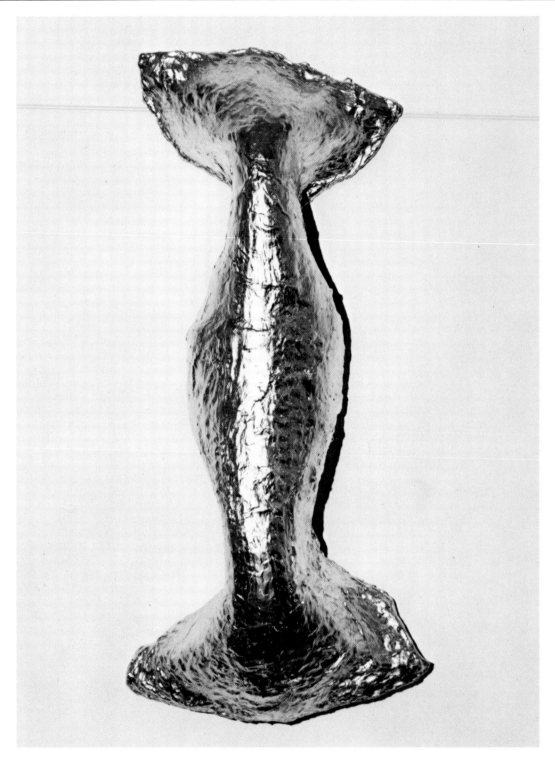

Rhodos, 1978. Gold leaf and gesso on plaster, cotton
bunting, and chicken wire, 55½ x 26 x 11" (141 x 66 x
27.9 cm). Texas Gallery, Houston.

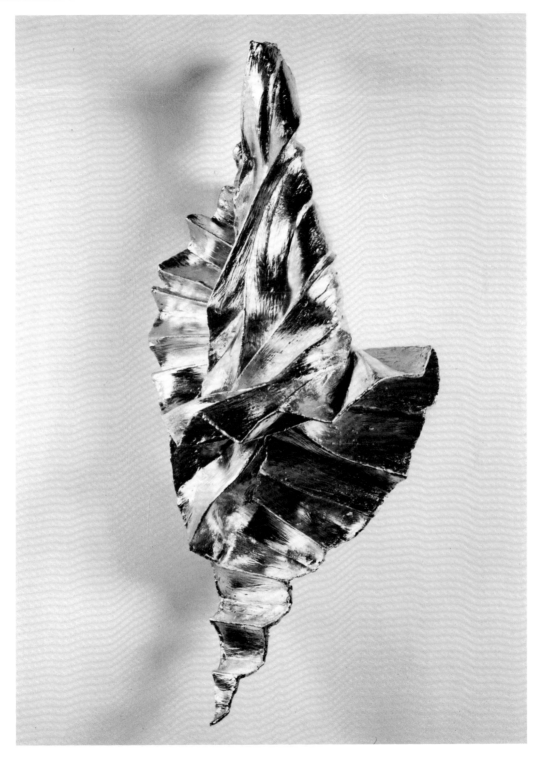

Shankh, 1980. Gold leaf and gesso on plaster and
bronze screen, 41 x 16 x 13" (104.4 x 40.6 x 33 cm).
Paula Cooper Gallery, New York.

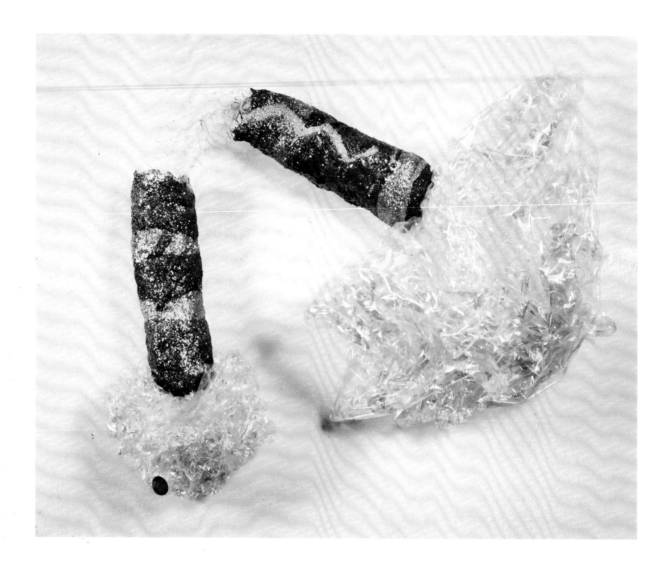

Mardi Gras (Lagniappe), 1977. Sparkle and gesso on
plaster, cotton bunting, and chicken wire, with
laminated polypropylene and polystyrene, 23 x 30 x 5″
(58.4 x 76.2 x 12.7 cm). Collection of Luiz M.S. Hafers.

LYNDA BENGLIS

Born in Lake Charles, Louisiana, 1941
Studied at Newcomb College, New Orleans
 (B.F.A., 1964)
Lives in New York

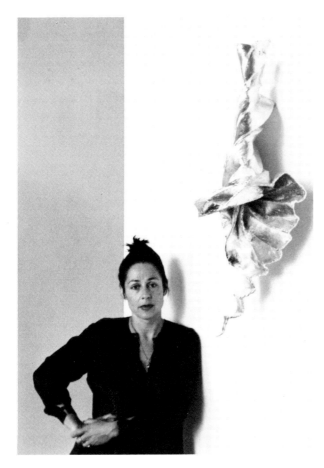

Selected Solo Exhibitions

1970 Paula Cooper Gallery, New York, "Lynda Benglis"
Janie C. Lee Gallery, Dallas, "Lynda Benglis"

1971 Paula Cooper Gallery, New York, "Lynda Benglis"
Hayden Gallery, Massachusetts Institute of
 Technology, Cambridge, "Lynda Benglis:
 Polyurethane Foam, 2 Component System"

1972 Hansen Fuller Gallery, San Francisco, "Lynda
 Benglis"

1973 The Clocktower, Institute for Art and Urban
 Resources, New York, "Lynda Benglis"
Paula Cooper Gallery, New York, "Lynda Benglis
 Video Tapes" (traveled to Video Gallery,
 Everson Museum of Art, Syracuse, New York)

Jack Glenn Gallery, Corona Del Mar, California,
 "Lynda Benglis"

1974 Paula Cooper Gallery, New York,
 "Metallized Knots"
Hansen Fuller Gallery, San Francisco, "Knots"
Texas Gallery, Houston, "Lynda Benglis"

1975 Paula Cooper Gallery, New York,
 "Lynda Benglis Sculpture"
Fine Arts Center Gallery, State University of
 New York, College at Oneonta, "Physical and
 Psychological Moments in Time." Exhibition
 catalogue, text by Robert Pincus-Witten
The Kitchen Center for Video, Music and
 Dance, New York, "Video Polaroids"
Texas Gallery, Houston, "Lynda Benglis"

1976 Paula Cooper Gallery, Los Angeles,
 "Lynda Benglis"

1977 Hansen Fuller Gallery, San Francisco,
 "Lynda Benglis"
Margo Leavin Gallery, Los Angeles, "7 Come 11"

1978 Paula Cooper Gallery, New York, "Lynda Benglis"

1979 Georgia State University Art Gallery, Atlanta,
 "Lynda Benglis: Recent Works." Exhibition
 brochure
Hansen Fuller Goldeen Gallery, San Francisco,
 "Bodies and Fans"
Texas Gallery, Houston, "New Work"

1980 Paula Cooper Gallery, New York, "Lynda Benglis"
Margo Leavin Gallery, Los Angeles,
 "Lynda Benglis"
Portland Center for the Visual Arts, Oregon,
 "Recent Works by Lynda Benglis"
Texas Gallery, Houston, "Fans (Air) Kites (Air)
 Airport (Air)"
University of South Florida, Tampa, "Lynda
 Benglis: 1968–1978" (traveled to Miami-Dade
 Community College, South Campus Art
 Gallery at the Lowe Art Museum, University
 of Miami). Exhibition catalogue, text by Peter
 Schjeldahl

1981 Galerie Albert Baronian, Brussels,
 "Lynda Benglis"
University of Arizona Museum of Art, Tucson,
 "Lynda Benglis." Exhibition catalogue

Selected Group Exhibitions

1969 Bykert Gallery, New York
The Detroit Institute of Arts, "Other Ideas."
 Exhibition catalogue, text by Samuel J. Wagstaff

Museum of Art, Finch College, New York, "Art and Process IV." Exhibition catalogue, text by Elayne H. Varian

Whitney Museum of American Art, New York, "1969 Annual Exhibition: Contemporary American Painting." Exhibition catalogue

1970 Paula Cooper Gallery, New York, "Drawing Show"

1971 Milwaukee Art Center, "Directions 3: Eight Artists." Exhibition catalogue, text by John Lloyd Taylor

Vassar College Art Gallery, Poughkeepsie, New York, "Twenty-Six by Twenty-Six." Exhibition catalogue, text by Marguerite Klobe

Walker Art Center, Minneapolis, "Works for New Spaces." Exhibition catalogue, text by Martin Friedman

1972 The Detroit Institute of Arts, "12 Statements Beyond the 60's." Exhibition catalogue

Indianapolis Museum of Art, "Painting and Sculpture Today, 1972." Exhibition catalogue, text by Richard L. Warrum

Walker Art Center, Minneapolis, "Painting: New Options." Exhibition catalogue, texts by Dean Swanson and Philip Larson

1973 Whitney Museum of American Art, New York, "1973 Biennial Exhibition: Contemporary American Art." Exhibition catalogue

Yale University Art Gallery, New Haven, Connecticut, "Options and Alternatives: Some Directions in Recent Art." Exhibition catalogue, text by Anne Coffin Hanson

1975 The Baltimore Museum of Art, "Fourteen Artists." Exhibition brochure, text by Brenda Richardson

The Clocktower, Institute for Art and Urban Resources, New York, "Selections from the Collection of Herbert and Dorothy Vogel" (traveled to the Institute of Contemporary Art of The University of Pennsylvania, Philadelphia, Contemporary Arts Center, Cincinnati). Exhibition catalogue, text by Suzanne Delehanty

Institute of Contemporary Art of The Univeristy of Pennsylvania, Philadelphia, "Video Art" (traveled to Contemporary Arts Center, Cincinnati, Museum of Contemporary Art, Chicago, Wadsworth Atheneum, Hartford, Connecticut). Exhibition catalogue, texts by David Antin, Lizzy Borden, and Jack Burnham

1976 Aarhus Kunstmuseum, Aarhus, Denmark, "The Liberation: Fourteen American Artists" (traveled internationally)

Art Gallery of New South Wales, Sydney, Australia, "Biennale of Sydney." Exhibition catalogue

1977 Museum of Contemporary Art, Chicago, "A View of a Decade." Exhibition catalogue, texts by Martin Friedman, Peter Gay, and Robert Pincus-Witten

New Orleans Museum of Art, "Five from Louisiana." Exhibition catalogue

1978 Stedelijk Museum, Amsterdam, "Made by Sculptors." Exhibition catalogue, text by Geert van Beijeren

1979 The Museum of Modern Art, New York, "Contemporary Sculpture: Selections from the Collection of The Museum of Modern Art." Exhibition catalogue, text by Kynaston McShine

Palazzo Reale, Milan, "Pittura Ambiente." Exhibition catalogue, texts by Francesca Alinovi and Renato Barilli

1980 Albright-Knox Art Gallery, Buffalo, New York, "With Paper, About Paper." Exhibition catalogue, text by Charlotta Kotik

American Pavilion, 39th Venice Biennale, "Drawings: The Pluralist Decade." Exhibition catalogue, text by Janet Kardon

Contemporary Arts Museum, Houston, "Extensions: Jennifer Bartlett, Lynda Benglis, Robert Longo, Judy Pfaff." Exhibition catalogue, text by Linda L. Cathcart

Museum of Contemporary Art, Chicago, "3 Dimensional Painting." Exhibition catalogue, text by Judith Tannenbaum

San Diego Museum of Art, "Sculpture in California 1975–1980." Exhibition catalogue, text by Richard Armstrong

Whitney Museum of American Art, New York, Downtown Branch, "Painting in Relief." Exhibition catalogue, text by Lisa Phillips

1981 Sculpture Center, New York, "Decorative Sculpture"

Whitney Museum of American Art, New York, "1981 Biennial Exhibition." Exhibition catalogue

SELECTED ARTICLES AND REVIEWS

Peter Schjeldahl, "New York Letter," *Art International,*
13 (September 1969), p.72.

Emily Wasserman, "New York," *Artforum,*
8 (September 1969), pp.59–60.

David Bourdon, "Fling, Dribble and Drip," *Life,*
February 12, 1970, pp.62–66.

Grace Glueck, "New York: Trendless but Varied, the
Season Starts," *Art in America,* 59 (September/
October 1971), pp.121–23.

Robert Pincus-Witten, "New York," *Artforum,*
10 (December 1971), p.79.

Klaus Kertess, "Foam Structures," *Art and Artists,*
7 (May 1972), pp.33–37.

Bruce Kurtz, "Video is Being Invented," *Arts Magazine,*
47 (December 1972/January 1973), pp.39–40.

Robert Morris, "Exchange 73," *Avalanche,* Summer/Fall
1973, pp.22–25.

Ellen Lubell, "Art Reviews," *Arts Magazine,*
48 (February 1974), p.68.

Vivien Raynor, "The Art of Survival (and Vice Versa),"
New York Times Magazine, February 17, 1974,
pp.48, 50.

Jeremy Gilbert-Rolfe, "Reviews," *Artforum,*
12 (March 1974), pp.69–70.

Hayden Herrera, "Reviews," *Art News,*
73 (September 1974), p.100.

Ann-Sargent Wooster, "New York," *Art in America,*
62 (September 1974), p.106.

Robert Pincus-Witten, "Lynda Benglis: The Frozen
Gesture," *Artforum,* 13 (November 1974), pp.54–59.
Reprinted in Robert Pincus-Witten, *Postminimalism*
(New York: Out of London Press, 1977).

Dorothy Seiberling, "The New Sexual Frankness:
Good-by to Hearts and Flowers," *New York,*
February 17, 1975, pp.37–44.

Cindy Nemser, "Four Artists of Sensuality,"
Arts Magazine, 49 (March 1975), pp.73–75.

Thomas B. Hess, "Review," *New York,*
December 8, 1975, p.114.

Ellen Lubell, "Arts Reviews," *Arts Magazine,*
50 (January 1976), p.17.

Ann-Sargent Wooster, "Reviews," *Artforum,*
14 (February 1976), pp.60–61.

France Morin, "Lynda Benglis in Conversation with
France Morin," *Parachute,* 6 (Spring 1977), pp.9–11.

Lucy R. Lippard, "You Can Go Home Again: Five
From Louisiana," *Art in America,*
65 (July/August 1977) pp.22–25.

Ellen Lubell, "Lynda Benglis," *Arts Magazine,*
53 (January 1979), p.14.

Rene Ricard, "Review of Exhibitions," *Art in America,*
67 (January 1979), pp.141–42.

"Lynda Benglis: Interview," *Ocular,* 4 (Summer 1979),
pp.30–43.

Kay Larson, "Avant to Be in Style," *The Village Voice,*
October 8, 1980, p.85.

Carrie Rickey, "Curatorial Conceptions: The Whitney's
Latest Sampler," *Artforum,* 19 (April 1981),
pp.52–57.

SCOTT BURTON: WORKS IN THE EXHIBITION

Table I, 1973
Stained oak, 21½ x 21 x 18″ (54.6 x 53.3 x 45.7cm)
Collection of the artist

Blue Granite Table, 1975–81
Blue granite, with metallic lacquer on steel,
29 x 60 x 32″ (73.7 x 152.4 x 81.3cm)
Collection of William N. Copley

Mother-of-Pearl Table, 1975–78
Galvanized steel and mother-of-pearl, 22 x 15¼ x 15¼″
(55.9 x 38.7 x 38.7cm)
Collection of the artist

Lawn Chair, 1977
Formica on wood, 43¾ x 31 x 51″
(111.1 x 78.7 x 129.5cm)
Collection of Robert Orton

Child's Table and Chair, 1978
Lacquered wood, with fabric, rubber, and steel: table,
21 x 22 x 17″ (53.3 x 55.9 x 43.2cm); chair, 27 x 12 x 12″
(68.6 x 30.5 x 30.5cm)
Collection of Doris and Charles Saatchi

Granite Chairs, 1978–81
Granite; two chairs, each 30 x 36¼ x 40″
(76.2 x 91.4 x 101.6cm)
Daniel Weinberg Gallery, San Francisco

Table for Two, 1979
Lacquered hot-rolled steel: table, 29 x 29 x 29″
(73.7 x 73.7 x 73.7cm); two chairs, each 32 x 20 x 20″
(81.3 x 50.8 x 50.8cm)
Collection of Michael Rea

Plywood Tripod Table, 1979–80
Plywood (edition of thirty), 21½ x 20 x 20″
(54.6 x 50.8 x 50.8cm)
Max Protetch Gallery, New York

Red Yellow Blue Cubes, 1979–80
Lacquered wood, 40½ x 30 x 30″ (102.9 x 76.2 x 76.2cm)
Collection of Barry Lowen

Ziggurat Table, 1980
Honduran mahogany, 20 x 39½ x 39½″
(50.8 x 100.3 x 100.3cm)
Collection of Alan Power

Pedestal Tables, 1980–81
Copper-plated bronze; two tables, each 37 x 11 x 11″
(94 x 27.9 x 27.9cm)
Max Protetch Gallery, New York

Tripod Table II, 1980–81
Steel (edition of ten), 20½ x 20½ x 20½″
(52.1 x 52.1 x 52.1cm)
Daniel Weinberg Gallery, San Francisco

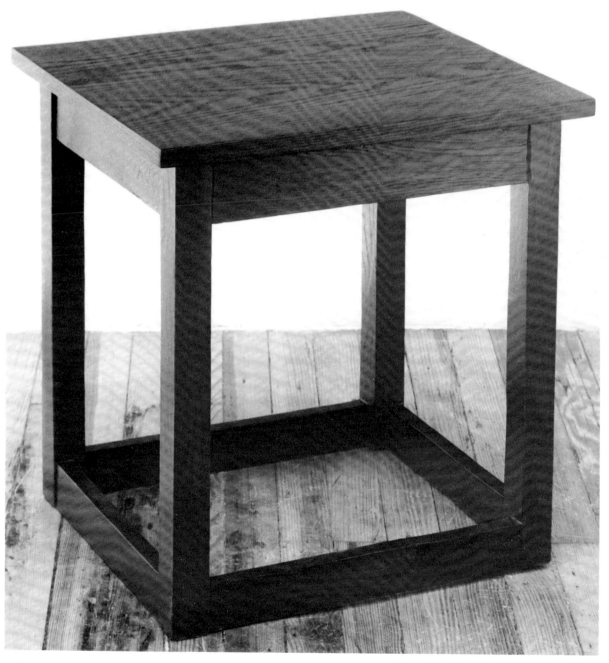

Table I, 1973. Stained oak, 21½ x 21 x 18″ (54.6 x 53.3 x 45.7 cm). Collection of the artist.

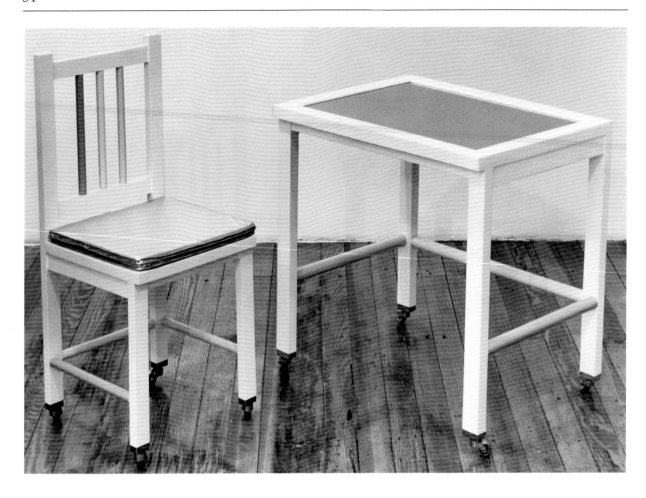

Child's Table and Chair, 1978. Lacquered wood, with fabric, rubber, and steel: table, 21 x 22 x 17" (53.3 x 55.9 x 43.2 cm); chair, 27 x 12 x 12" (68.6 x 30.5 x 30.5 cm). Collection of Doris and Charles Saatchi.

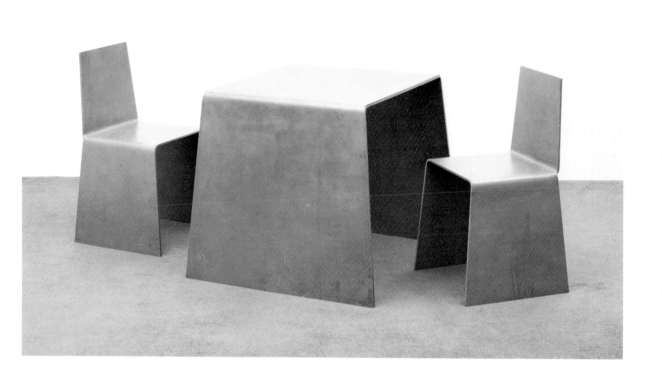

Table for Two, 1979. Lacquered hot-rolled steel: table, 29
x 29 x 29″ (73.7 x 73.7 x 73.7 cm); two chairs, each 32 x
20 x 20″ (81.3 x 50.8 x 50.8 cm). Collection of Michael Rea.

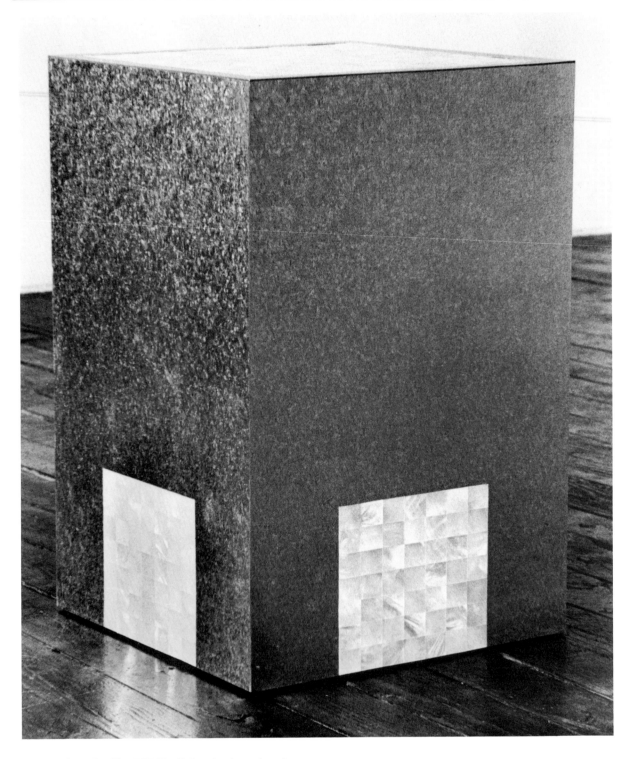

Mother-of-Pearl Table, 1975-78. Galvanized steel and
mother-of-pearl, 22 x 15¼ x 15¼″ (55.9 x 38.7 x
38.7 cm). Collection of the artist.

Pedestal Table, 1980–81. Gilt bronze, 37 x 11 x 11″ (94 x
27.9 x 27.9 cm). Private collection.

Ziggurat Table, 1980. Honduran mahogany, 20 x 39½ x
39½" (50.8 x 100.3 x 100.3 cm). Collection of Alan Power.

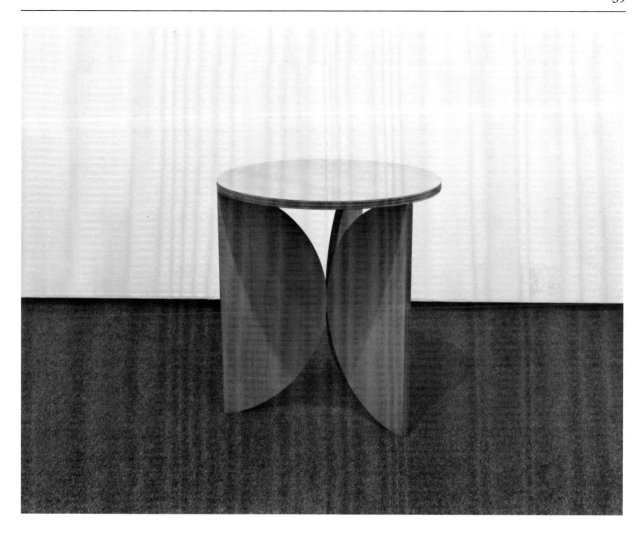

Plywood Tripod Table, 1979–80. Plywood (edition of
thirty), 21½ x 20 x 20″ (54.6 x 50.8 x 50.8 cm).
Max Protetch Gallery, New York.

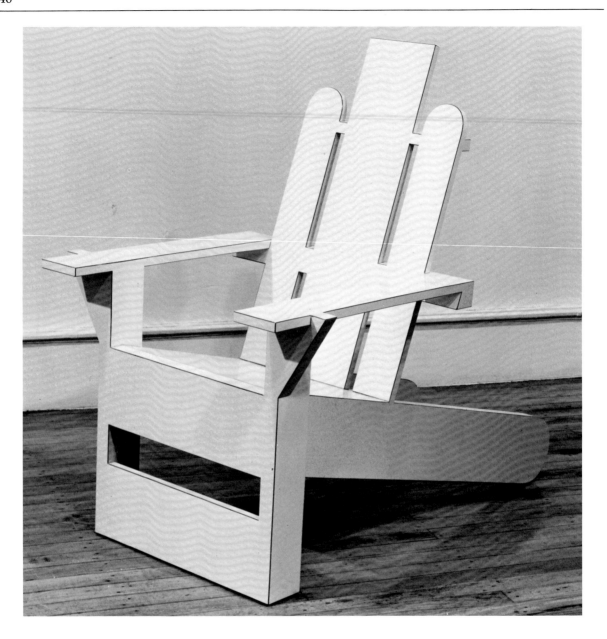

Lawn Chair, 1977. Formica on wood, 43¾ x 31 x 51″
(111.1 x 78.7 x 129.5 cm). Collection of Robert Orton.

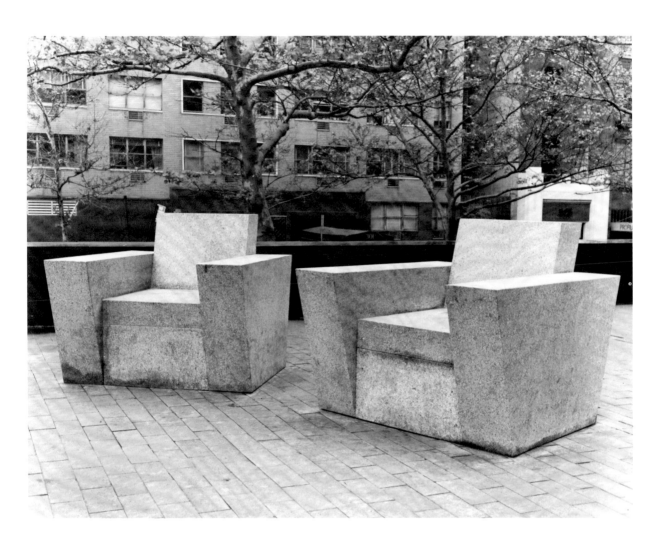

Granite Chairs, 1978–81. Granite; two chairs, each 30 x
36½ x 40″ (76.2 x 91.4 x 101.6 cm). Daniel Weinberg Gallery,
San Francisco.

SCOTT BURTON

Born in Greensboro, Alabama, 1939
Studied at Columbia University, New York
 (B.A., 1962); New York University (M.A., 1963)
Lives in New York

SELECTED SOLO EXHIBITIONS

1975 Artists Space, New York, "Two Chair Pieces"

1977 Droll/Kolbert Gallery, New York,
 "Pragmatic Structures: Tables and Chairs"

1978 Brooks Jackson Gallery Iolas, New York,
 "Four Tables"

1979 Protetch-McIntosh Gallery, Washington, D.C.,
 "Sculpture Equals Furniture"

1980 Daniel Weinberg Gallery, San Francisco,
 "Recent Sculpture"

1981 The Dag Hammarskjöld Plaza Sculpture
 Garden, New York, "Granite Chairs, a Pair"
 Max Protetch Gallery, New York, "New Tables"

SELECTED GROUP EXHIBITIONS

1970 University of Iowa Museum of Art, Iowa City,
 "Two Evenings" (outdoor installation:
 Furniture Landscape)

1975 Whitney Museum of American Art, New York,
 "1975 Biennial Exhibition: Contemporary
 American Art." Exhibition catalogue

1976 Akademie der Künste, West Berlin,
 "New York—Downtown Manhattan: SoHo"
 (traveled to Louisiana Museum, Humlebaek,
 Denmark). Exhibition catalogue, texts by
 Werner Duttmann and Lucy R. Lippard
 Parrish Art Museum, Southampton, New York,
 "Public Spaces"
 P.S.1, Institute for Art and Urban Resources,
 Long Island City, New York, "Rooms P.S.1."
 Exhibition catalogue, text by Alanna Heiss

1977 Institute of Contemporary Art of The University
 of Pennsylvania, Philadelphia,
 "Improbable Furniture" (traveled to La Jolla
 Museum of Contemporary Art, California,
 and Museum of Contemporary Art, Chicago).
 Exhibition catalogue, texts by Suzanne
 Delehanty and Robert Pincus-Witten
 Museum of Contemporary Art, Chicago,
 "A View of a Decade." Exhibition catalogue,
 texts by Martin Friedman, Peter Gay, and
 Robert Pincus-Witten
 The Museum of the American Foundation for
 the Arts, Miami, "Patterning and Decoration."
 Exhibition catalogue, text by Amy Goldin

1978 The Solomon R. Guggenheim Museum,
 New York, "Young American Artists: 1978
 Exxon National Exhibition." Exhibition
 catalogue, text and interviews by Linda Shearer
 Holly Solomon Gallery, New York, "Gold/Silver"

1979 Artists Space, New York, "Sixth Anniversary
 Exhibition"
 The Detroit Institute of Arts, "Image
 and Object in Contemporary Sculpture"
 (traveled to P.S.1, Institute for Art and Urban
 Resources, Long Island City, New York).
 Exhibition catalogue, text by Jay Belloli
 Neuberger Museum, State University of New
 York, College at Purchase, "Ten Artists/Artists
 Space." Exhibition catalogue, text by
 Helene Winer

1980 Marian Goodman Gallery, New York,
 "Further Furniture." Exhibition brochure,
 text by Nicolas Calas
 The Grey Art Gallery and Study Center,
 New York University, "Perceiving Modern
 Sculpture: Selections for the Sighted and
 Non-Sighted." Exhibition catalogue
 Indianapolis Museum of Art,
 "Painting and Sculpture Today, 1980."
 Exhibition catalogue
 Institute of Contemporary Art of The University
 of Pennsylvania, Philadelphia,
 "Material Pleasures" (traveled to Museum of
 Contemporary Art, Chicago). Exhibition
 catalogue, text by Michael A. Quigley

Otis/Parsons Gallery, Otis Art Institute of Parsons School of Design, Los Angeles, "Furnishings by Artists." Exhibition catalogue, text by Howard Singerman

1981 Art Gallery, Myers Fine Arts Building, State University of New York, College at Plattsburgh, "Usable Art." Exhibition catalogue, text by John Perreault
Wave Hill, Bronx, New York, "Tableaux." Exhibition catalogue, text by Kim Levin
Whitney Museum of American Art, New York, "1981 Biennial Exhibition." Exhibition catalogue

SELECTED PERFORMANCES

1970 University of Iowa Museum of Art, Iowa City, "Two Evenings"
Wadsworth Atheneum, Hartford, Connecticut, "Four Theater Pieces"

1971 Finch College, New York, "18 Pieces"

1972 American Theater Lab, New York, *Group Behavior Tableaux*
Whitney Museum of American Art, New York, "Spring Festival" (performance: *Group Behavior Tableaux*)

1973 Allen Memorial Art Museum, Oberlin, Ohio, "Festival of Contemporary Arts." Brochure, text by Athena T. Spear
Museum of Fine Arts, Boston, "Five Evenings"

1974 Artists Space, New York, "Persona"

1975 Fine Arts Building, New York, "Lives"

1976 The Solomon R. Guggenheim Museum, New York, *Pair Behavior Tableaux.* Brochure, text by Linda Shearer

1977 Kassel, West Germany, Documenta 6

1980 University Art Museum, University of California, Berkeley, *Individual Behavior Tableaux.* Brochure, text by Michael Auping

SELECTED ARTICLES AND REVIEWS

John Perreault, "A Dance of Silent Victims," *The Village Voice*, April 27, 1972, p.32.

Harris Rosenstein, "Reviews and Previews," *Art News*, 71 (Summer 1972), p.14.

Roberta Smith, "Galleries," *Arts Magazine*, 47 (December 1972/January 1973), pp.81–82.

Scott Burton, "Make a Political Statement," *Art-Rite*, no. 6 (Summer 1974), p.24.

Amy Goldin, "The New Whitney Biennial: Pattern Emerging?" *Art in America*, 63 (May/June 1975) pp.72–73.

Edit de Ak and Walter Robinson, "An Article on Scott Burton in the Form of a Resumé," *Art-Rite*, no. 8 (Winter 1975) pp.8–10.

Carter Ratcliff, "Reviews," *Artforum*, 14 (March 1976), pp.60–61.

John Perreault, "Burton's Robot Lovers," *SoHo Weekly News*, March 11, 1976, p.16.

Steven Simmons, "Reviews," *Artforum*, 14 (May 1976), pp.66–67.

Robert Pincus-Witten, "Scott Burton: Conceptual Performance as Sculpture," *Arts Magazine*, 51 (September 1976), pp.112–17. Reprinted in Robert Pincus-Witten, *Postminimalism* (New York: Out of London Press, 1977).

Gregory Battcock, "Three Artists—Three New Ideas," *New York Arts Journal*, no. 10 (1978), p.31.

John Howell, "Acting/Non-Acting: Interview with Scott Burton," *Performance Art Magazine*, no. 2 (1978), pp.7–10.

Carter Ratcliff, "New York Letter," *Art International*, 22 (January 1978), pp.86–87.

Robert Pincus-Witten, "Camp Meetin: The Furniture Pieces of Scott Burton," *Arts Magazine*, 53 (September 1978), pp.103–5.

Roberta Smith, "Scott Burton: Designs on Minimalism," *Art in America*, 66 (November/December 1978), pp.138–40.

Carrie Rickey, "Art of Whole Cloth," *Art in America*, 67 (November 1979), pp.79–80, 83.

Nancy Foote, ed., "Situation Esthetics," *Artforum*, 18 (January 1980), pp.22–23.

Robert McDonald, "The Utility of Beauty," *Artweek*, February 23, 1980, p.16.

Michael Auping, "Scott Burton: Individual Behavior Tableaux," *Images and Issues*, 1 (Summer 1980), pp.46–47.

Scott Burton, "Furniture Journal: Rietveld," *Art in America*, 68 (November 1980), pp.102–8.

Edward de Celle and Mark Thompson, "A Performance Artist in Profile," *The Advocate*, January 22, 1981, pp.T7–T11.

Roberta Smith, "Biennial Blues," *Art in America*, 69 (April 1981), pp.93, 95.

John Romine, "Scott Burton: Interview," *Upstart*, 5 (May 1981), pp.6–9.

DONNA DENNIS: WORKS IN THE EXHIBITION

Egyptian Hotel, 1972
Acrylic on wood and masonite; mirror; sandbag;
painted wood, cloth, and paper palm tree,
68½ x 67 x 16" (174 x 170.2 x 40.6 cm)
Collection of the artist, courtesy Holly Solomon
Gallery, New York

Hotel Pacifica, 1972
Acrylic and charcoal on wood and masonite;
fluorescent light; sandbag; painted wood, cloth, and
paper palm tree, 68½ x 70 x 18"
(174 x 177.8 x 45.7 cm)
Collection of the artist

Bird Hotel, 1973
Acrylic on wood and masonite; sandbag; painted
wood, cloth, and paper palm tree, 73 x 70 x 9"
(185.4 x 177.8 x 22.9 cm)
Collection of the artist, courtesy Holly Solomon
Gallery, New York

Station Hotel, 1973–74
Acrylic on wood and masonite, with fluorescent and
incandescent lights, 75 x 72 x 13½"
(190.5 x 182.9 x 34.3 cm)
Collection of Dr. Donald Dworken

Subway Station with Lighted Interior, 1974
Acrylic and enamel on wood and masonite, with
incandescent light, 74 x 43½ x 32"
(188 x 110.5 x 81.3 cm)
Collection of Holly and Horace Solomon

Subway Station with Yellow and Blue, 1974–76
Acrylic and enamel on wood, masonite, and metal,
with fluorescent and incandescent lights,
79 x 49 x 65½" (200.7 x 124.4 x 166.4 cm)
Neue Galerie—Sammlung Ludwig, Aachen,
West Germany

Tourist Cabin (Pensacola), 1976
Acrylic and enamel on wood and masonite, with
glass, plastic, metal screen, wallpaper, and incan-
descent light, 78 x 54½ x 72" (198.1 x 138.4 x 182.9 cm)
Collection of the artist, courtesy Holly Solomon
Gallery, New York

Tunnel Tower, 1979–80
Acrylic and enamel on wood and masonite, with
glass, metal, and fluorescent, incandescent, and neon
lights, 138 x 56 x 62" (350.5 x 142.2 x 157.5 cm)
Collection of the artist, courtesy Holly Solomon
Gallery, New York

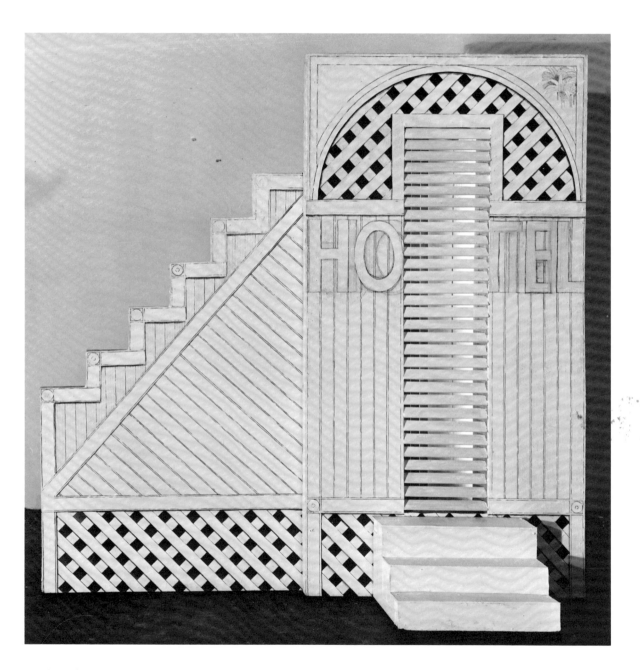

Hotel Pacifica, 1972. Acrylic and charcoal on wood and masonite; fluorescent light; sandbag; painted wood, cloth, and paper palm tree, 68½ x 70 x 18″ (174 x 177.8 x 45.7 cm). Collection of the artist.

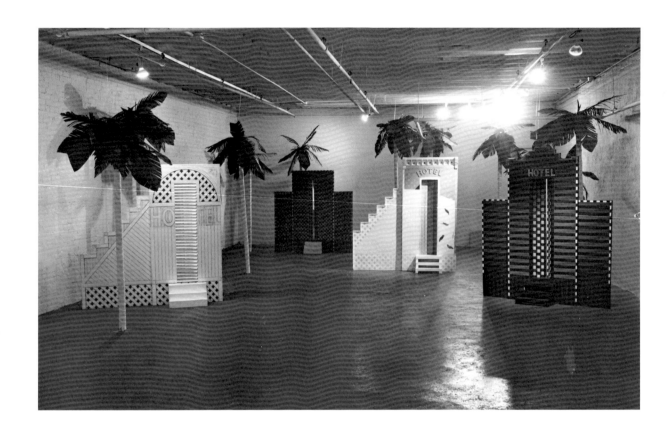

Installation view of the exhibition "Hotels,"
Westbroadway Gallery, New York, 1973. From left to
right: *Hotel Pacifica, Egyptian Hotel, Bird Hotel, Dark Hotel*.

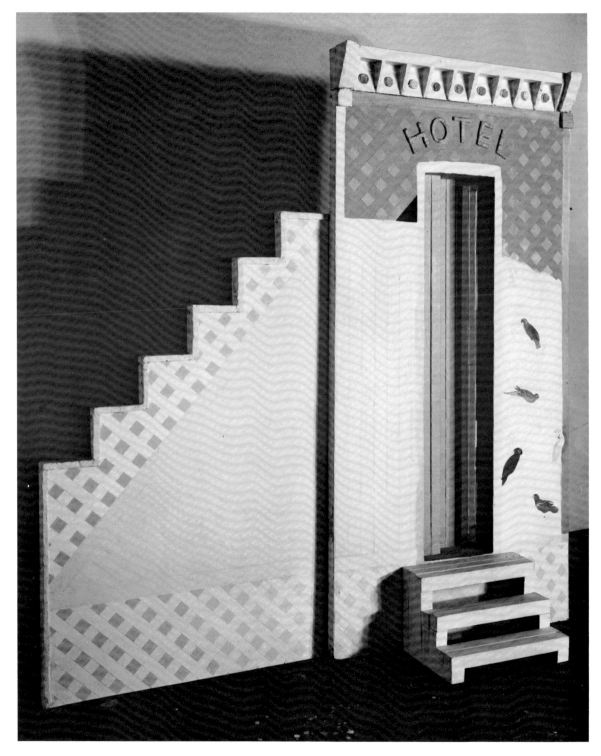

Bird Hotel, 1973. Acrylic on wood and masonite; sandbag;
painted wood, cloth, and paper palm tree, 73 x 70 x 9"
(185.4 x 177.8 x 22.9 cm). Holly Solomon Gallery, New York.

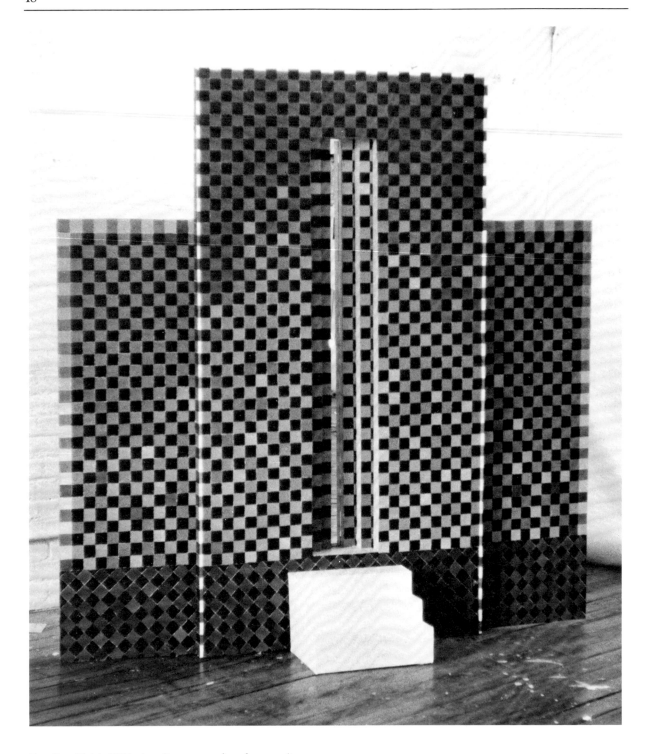

Egyptian Hotel, 1972. Acrylic on wood and masonite;
mirror; sandbag; painted wood, cloth, and paper palm
tree, 68½ x 67 x 16″ (174 x 170.2 x 40.6 cm). Holly
Solomon Gallery, New York.

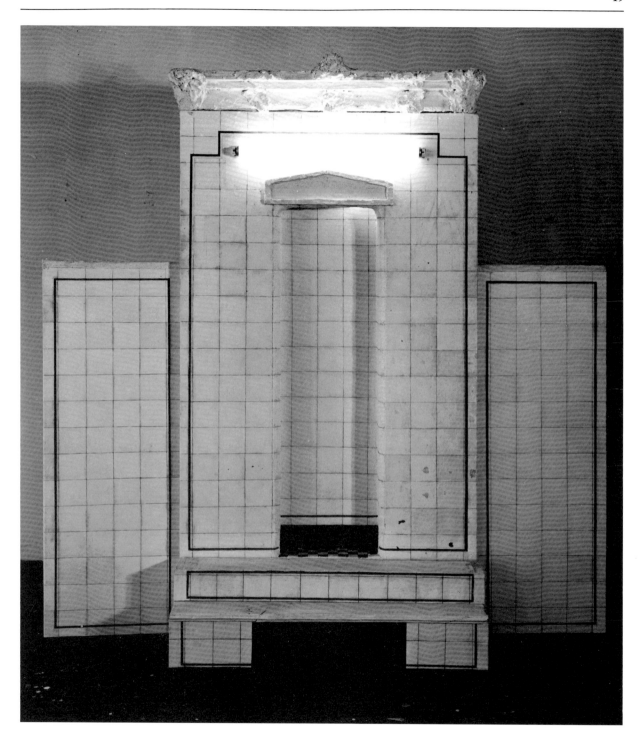

Station Hotel, 1973–74. Acrylic on wood and masonite, with fluorescent and incandescent lights, 75 x 72 x 13½″ (190.5 x 182.9 x 34.3 cm). Collecton of Dr. Donald Dworken.

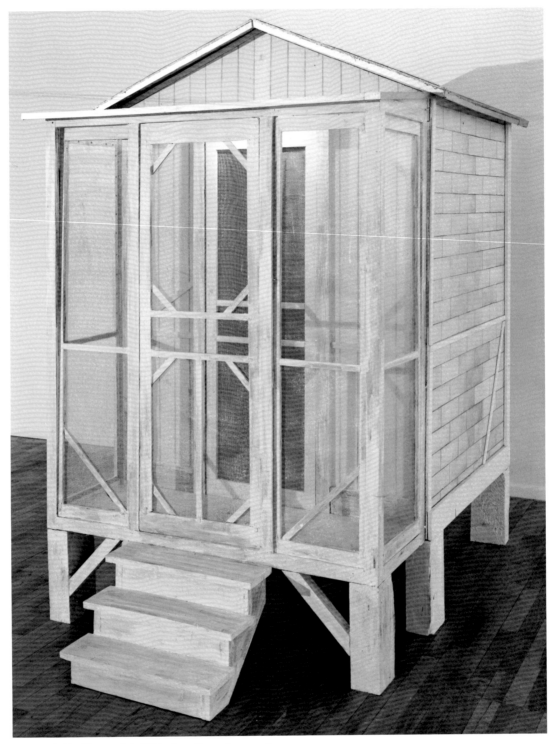

Tourist Cabin (Pensacola), 1976. Acrylic and enamel on
wood and masonite, with glass, plastic, metal screen,
wallpaper, and incandescent light, 78 x 54½ x 72"
(198.1 x 138.4 x 182.9 cm). Holly Solomon Gallery, New York.

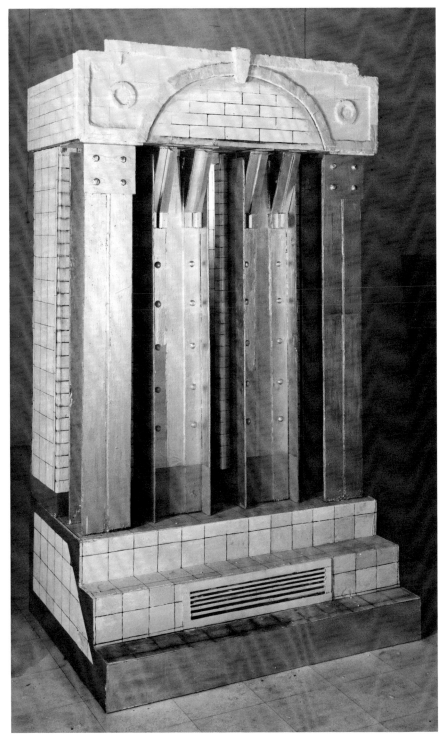

Subway Station with Lighted Interior, 1974. Acrylic and
enamel on wood and masonite, with incandescent
light, 74 x 43½ x 32″ (188 x 110.5 x 81.3 cm). Collection
of Holly and Horace Solomon.

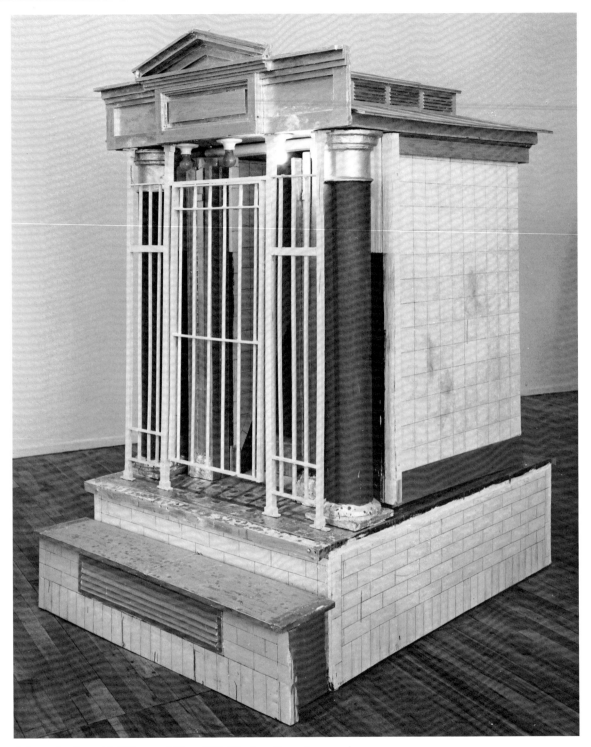

Subway Station with Yellow and Blue, 1974–76. Acrylic and enamel on wood, masonite, and metal, with fluorescent and incandescent lights, 79 x 49 x 65½″ (200.7 x 124.4 x 166.4 cm). Neue Galerie—Sammlung Ludwig, Aachen, West Germany.

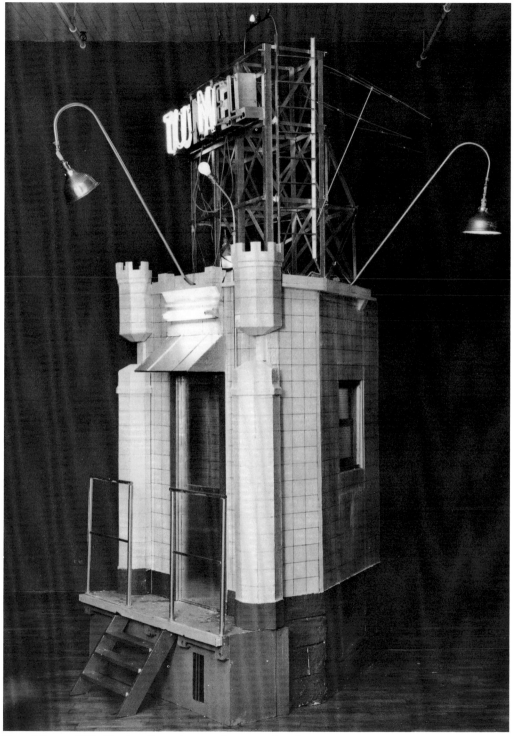

Tunnel Tower, 1979–80. Acrylic and enamel on wood and masonite, with glass, metal, and fluorescent, incandescent, and neon lights, 138 x 56 x 62″ (350.5 x 142.2 x 157.5 cm). Holly Solomon Gallery, New York.

DONNA DENNIS

Born in Springfield, Ohio, 1942
Studied at Carleton College, Northfield, Minnesota
 (B.A., 1964); College Art Studies Abroad,
 Paris (1964–65); The Art Students League of New
 York (1965–66)
Lives in New York

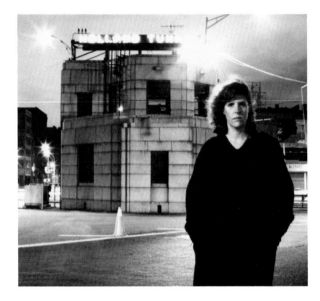

SELECTED SOLO EXHIBITIONS

1973 Westbroadway Gallery, New York, "Hotels"

1974 Wilcox Gallery, Swarthmore College,
 Swarthmore, Pennsylvania, "Donna Dennis"

1976 Holly Solomon Gallery, New York,
 "Tourist Cabins and Subway Stations"

1977 Musical Theater Lab, John F. Kennedy Center
 for the Performing Arts, Washington, D.C.,
 "City Stations and Country Stops"

1978 Adler Gallery, Los Angeles, "Maquettes and
 Drawings"
 Holly Solomon Gallery, New York, "Donna
 Dennis"

1979 Contemporary Arts Center, Cincinnati,
 "Three Sculptures by Donna Dennis."
 Exhibition catalogue, text by Pat Thomson

1980 Ohio State University, Columbus,
 "Donna Dennis"
 Holly Solomon Gallery, New York,
 "Drawings and Maquettes"
 Holly Solomon Gallery, New York,
 "New York and New Jersey"

1981 Locus Solus Gallery, Genoa, Italy,
 "Maquettes and Drawings"

SELECTED GROUP EXHIBITIONS

1972 Artists' studios, New York, "Ten Downtown"
 Westbroadway Gallery, New York,
 "Inaugural Show"

1973 A.I.R. Gallery, New York, "A.I.R. Invitational"
 A.I.R. Gallery, New York, "Open A.I.R."

1974 The Aldrich Museum of Contemporary Art,
 Ridgefield, Connecticut,
 "Contemporary Reflections, 1973–74."
 Exhibition catalogue, text by Larry Aldrich
 Forum Gallery, New York, "New Talent"
 Portland Museum of Art, Maine,
 "19 Women Artists"
 University Art Gallery, State University of New
 York at Albany, "Eccentrics and Fantastics"
 (traveled to Brainerd Art Gallery, State
 University of New York at Potsdam).
 Exhibition brochure, text by Donald Cole.

1975 Holly Solomon Gallery, New York,
 "Group Show"

1976 Art Museum of South Texas, Corpus Christi,
 "Purchase Show"

1977 Brainerd Art Gallery, State University of New
 York at Potsdam, "Sculpture: Potsdam '77."
 Exhibition catalogue, text by Benedict
 Goldsmith
 112 Greene Street Gallery, New York,
 "Ten Downtown Documentation Show"
 P.S.1, Institute for Art and Urban Resources,
 Long Island City, New York,
 "Ten Years of Ten Downtown"
 Holly Solomon Gallery, New York,
 "Sculptors' Drawings"
 Visual Arts Museum, School of Visual Arts,
 New York, "A Question of Scale"
 Walker Art Center, Minneapolis,
 "Scale and Environment." Exhibition
 catalogue, text by Lisa Lyons
 Whitney Museum of American Art, New York,
 Downtown Branch, "Small Objects."
 Exhibition brochure

1978 Carleton College, Northfield, Minnesota,
 "Three Alumni"

 Institute of Contemporary Art of The University
 of Pennsylvania, Philadelphia, "Dwellings"
 (traveled to Neuberger Museum, State
 University of New York, College at Purchase).
 Exhibition catalogue, text by Lucy R. Lippard

Mandeville Art Gallery, University of California,
San Diego, "Micro-Sculpture: Small Scale
Tableaux and Architectural Sculptures"

San Francisco Art Institute, "New York."
Exhibition catalogue, text by Helene Fried

Holly Solomon Gallery, New York,
"Gold/Silver"

Whitney Museum of American Art, New York,
Downtown Branch, "Architectural
Analogues." Exhibition brochure, text by Lisa
Phillips

1979 Freedman Art Gallery, Albright College,
Reading, Pennsylvania, "Small is Beautiful"
(traveled to Bucknell University, Lewisburg,
Pennsylvania)

Hirshhorn Museum and Sculpture Garden,
Smithsonian Institution, Washington, D.C.,
"Directions." Exhibition catalogue, text by
Howard N. Fox

Whitney Museum of American Art, New York,
"1979 Biennial Exhibition." Exhibition
catalogue

1980 Alessandra Gallery, New York,
"Benefit for Heresies"

Indianapolis Museum of Art,
"Painting and Sculpture Today, 1980."
Exhibition catalogue

Los Angeles Institute of Contemporary Art,
"Architectural Sculpture." Exhibition
catalogue, texts by Debra Burchett, Susan C.
Larsen, Lucy R. Lippard, and Melinda Wortz

Neue Galerie—Sammlung Ludwig, Aachen,
West Germany, "Les Nouveaux Fauves—Die
Neuen Wilden." Exhibition catalogue, text by
Wolfgang Becker

1981 City Beautiful Council, Dayton, Ohio (outdoor
installation: *The Mad River Tunnel)*

First Street Forum Gallery, St. Louis,
"Inner/Urban." Exhibition catalogue, text by
Ruth K. Meyer

The Grey Art Gallery and Study Center,
New York University, "Benefit for Heresies"

Women's Hall of Fame, Seneca Falls, New York,
"Homework: The Domestic Environment
Reflected in the Work of Contemporary
Women Artists" (traveled to Joe & Emily
Lowe Art Gallery, Syracuse University,
Syracuse, New York)

SELECTED ARTICLES AND REVIEWS

Gerrit Henry, "Reviews and Previews: Ten
Downtown," *Art News*, 71 (April 1972), p.66.

Rosemary Mayer, "New York Galleries: Attitudes
Towards Materials, Content and the Personal,"
Arts Magazine, 47 (May/June 1973), p.66.

Gerrit Henry, "Reviews and Previews," *Art News*,
72 (Summer 1973), p.93.

Carter Ratcliff, "New York Letter," *Art International*,
17 (Summer 1973), pp.62, 99.

Phyllis Derfner, "New York Letter," *Art International*,
17 (September 1973), p.41.

Lawrence Alloway, "New Talent Show," *The Nation*,
June 29, 1974, p.830.

Mona da Vinci, "Holly Solomon Opening Show,"
SoHo Weekly News, September 18, 1975, p.15.

Carter Ratcliff, "Notes on Small Sculpture," *Artforum*,
14 (April 1976), pp.35–42.

Barbara Barracks, "New York Reviews," *Artforum*,
15 (February 1977), p.67.

Alfred Frankenstein, "Inventiveness Is the Thread,"
San Francisco Chronicle, February 2, 1978, p.43.

Grace Glueck, "Art: Sculptural Trips into Built
Fantasies," *New York Times*, March 16, 1978, p.C24.

John Ashbery, "Anxious Architecture," *New York*,
October 16, 1978, pp.161–62.

Susan Larsen, "The Nation," *Art News*,
78 (February 1979), p.143.

Hilton Kramer, "Variety of Styles at the Whitney
Biennial," *New York Times*, February 16, 1979, p.C17.

John Ashbery, "Decoration Days," *New York*,
July 2, 1979, p.52.

Francesca Alinovi, "Artists' Architecture," *Domus*,
604 (March 1980), p.34.

Barbara Radici, "They Call It Architectural Sculpture,"
Casa Vogue, 107 (March 1980), p.155.

William Zimmer, "Donna Dennis," *SoHo Weekly News*,
March 26, 1980, p.78.

James Jordan, "Light: Adams, Dennis and Sonneman,"
Dialogue, March/April 1980, p.25.

Kay Larson, "Between Rocks and Hard Places,"
The Village Voice, April 7, 1980, p.69.

Donna Dennis, "The Presence of the Past," *Domus*,
610 (October 1980), pp.124–25.

John Duff: Works in the Exhibition

Curved Channel, 1970
Fiberglass and aluminum paint, 93 x 18 x 18"
(236.2 x 45.7 x 45.7cm)
Collection of the artist

Duct Piece, 1970
Fiberglass and aluminum paint, 31 x 131 x 11"
(78.7 x 332.7 x 27.9cm)
Collection of the artist

Large Oval II, 1971
Fiberglass and paint, 48¼ x 70¼ x 48"
(122.6 x 178.4 x 121.9cm)
Collection of the artist

Orange Horizontal Spear, 1971–72
Fiberglass and red lead paint, 14¼ x 89 x 2½"
(36.2 x 226.1 x 5.7cm)
Collection of the artist

Orange Wedge, 1972
Fiberglass and red lead paint, 72 x 8¼ x 12¼"
(182.9 x 21 x 31.1cm)
Collection of the artist

White Wall Piece, 1972
Fiberglass, paint, and wood, 84 x 14 x 10"
(213.4 x 35.6 x 25.4cm)
Whitney Museum of American Art, New York;
Gift of Hornick Industries, Inc. 77.119

Curved Wedge, 1972–73
Fiberglass, 72 x 6 x 16" (182.9 x 15.2 x 40.6cm)
Collection of Edward Albee

Orange Needle Piece, 1973
Fiberglass and red lead paint, 71½ x 5¾ x 4¼"
(181.6 x 14.6 x 10.8cm)
Collection of the artist

Extended Polygon No. 3, 1974
Fiberglass and brick exterior paint, 65⅛ x 7¼ x 4⅞"
(165.4 x 18.4 x 12.4cm)
The Solomon R. Guggenheim Museum, New York

Extended Triangle, 1974
Fiberglass and brick exterior paint, 71 x 7½ x 6"
(180.3 x 19.1 x 15.2cm)
Institute of Contemporary Art, Boston

Two Part Column, 1974
Fiberglass and brick exterior paint, 70½ x 7¼ x 17¾"
(179.1 x 18.4 x 45.6cm)
Collection of Barbara Rose

Rietveld Column, 1975
Painted wood and iron, 73¼ x 10½ x 10½"
(186.1 x 26.7 x 26.7cm)
Collection of the artist, courtesy Daniel Weinberg
Gallery, San Francisco

Spiral Relief No. 2, 1975
Painted wood with glass, 64 x 46½ x ⅝"
(162.6 x 118.1 x 1.6cm)
Collection of the artist

Corten Piece, 1976
Corten steel, 46 x 27 x 27" (116.8 x 68.6 x 68.6cm)
Collection of the artist

Architectural Object, 1978
Welded and painted steel rods, 52 x 72 x 72"
(132.1 x 182.9 x 182.9cm)
Collection of the artist, courtesy Daniel Weinberg
Gallery, San Francisco

Green and Orange Floor Piece, 1978
Welded and painted steel rods, 18 x 48 x 48"
(45.7 x 121.9 x 121.9cm)
Collection of William Katz

Two Rectangle Floor Piece, 1978
Welded steel rods, 72 x 72 x 12"
(182.9 x 182.9 x 30.5cm)
Collection of the artist

A1, 1981
Bronze, 12 x 35½ x 15"
(30.4 x 90.2 x 38.1cm)
Margo Leavin Gallery, Los Angeles

C1, 1981
Bronze, 12 x 48 x 24"
(30.5 x 121.9 x 61cm)
Margo Leavin Gallery, Los Angeles

JOHN DUFF

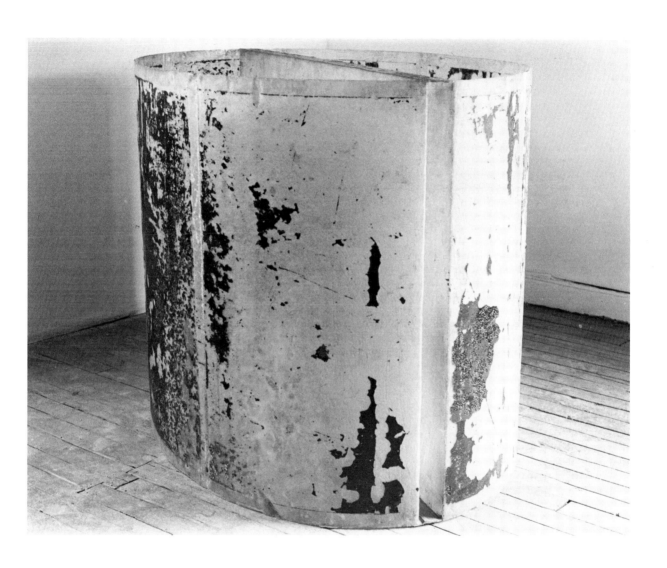

Large Oval II, 1971. Fiberglass and paint, 48¼ x 70¼ x 48" (122.6 x 178.4 x 121.9 cm). Collection of the artist.

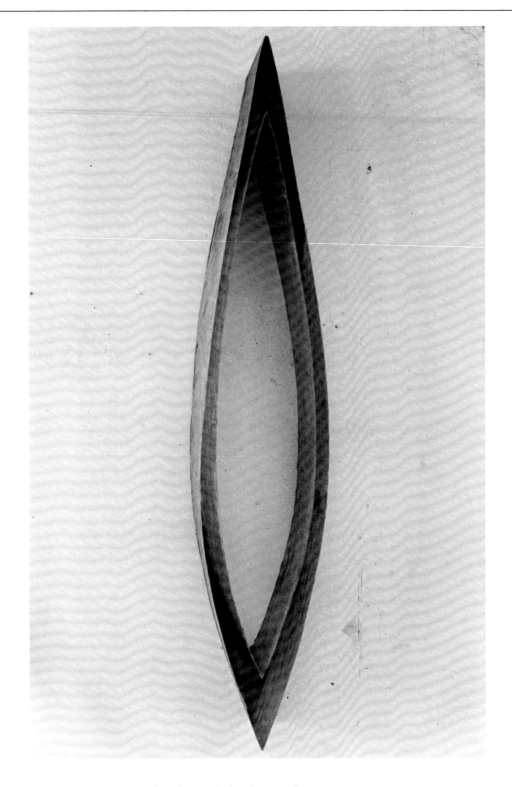

Curved Channel, 1970. Fiberglass and aluminum paint,
93 x 18 x 18" (236.2 x 45.7 x 45.7 cm). Collection of the artist.

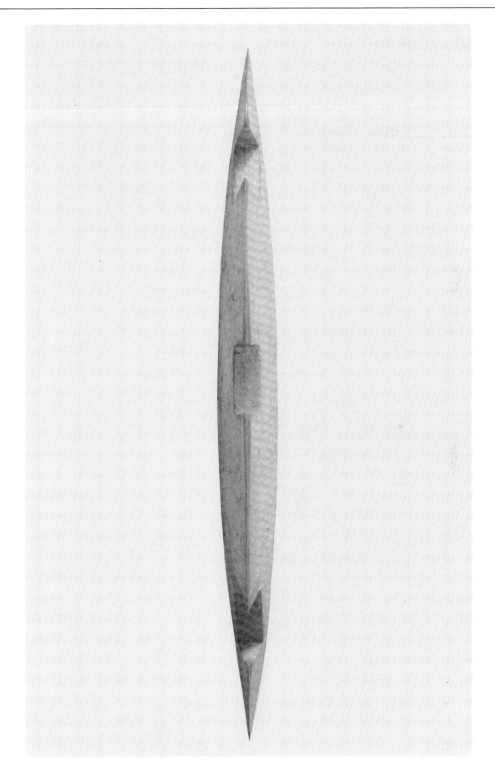

Curved Wedge, 1972–73. Fiberglass, 72 x 6 x 16″ (182.9 x 15.2 x 40.6 cm). Collection of Edward Albee.

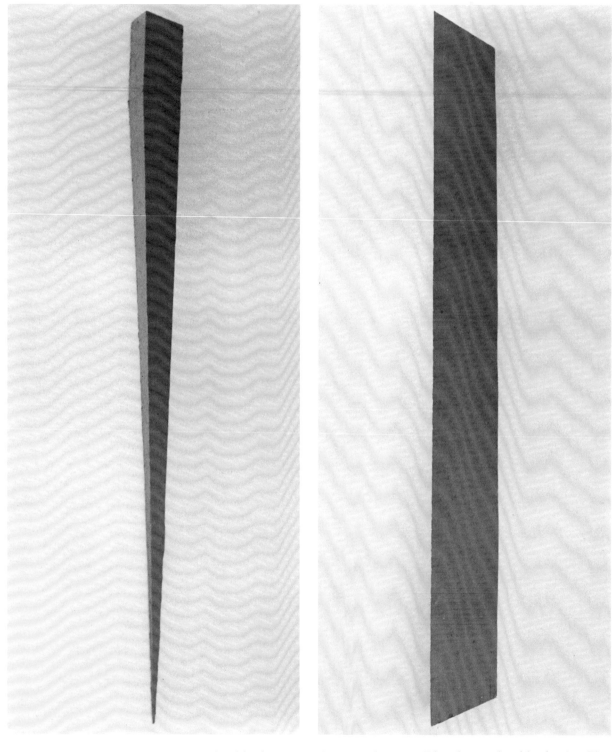

Orange Needle Piece, 1973. Fiberglass and red lead paint, 71½ x 5¾ x 4¼" (181.6 x 14.6 x 10.8 cm). Collection of the artist.

Orange Wedge, 1972. Fiberglass and red lead paint, 72 x 8¼ x 12¼" (182.9 x 21 x 31.1 cm). Collection of the artist.

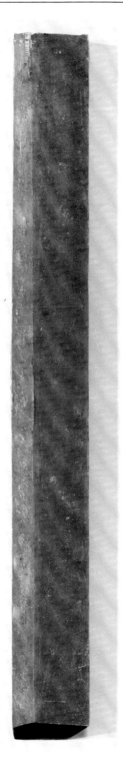

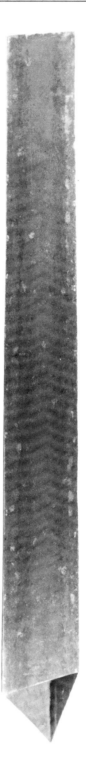

Extended Polygon No. 3, 1974. Fiberglass and brick exterior paint, 65⅛ x 7¼ x 4⅞″ (165.4 x 18.4 x 12.4 cm). The Solomon R. Guggenheim Museum, New York.

Extended Triangle, 1974. Fiberglass and brick exterior paint, 71 x 7½ x 6″ (180.3 x 19.1 x 15.2 cm). Institute of Contemporary Art, Boston.

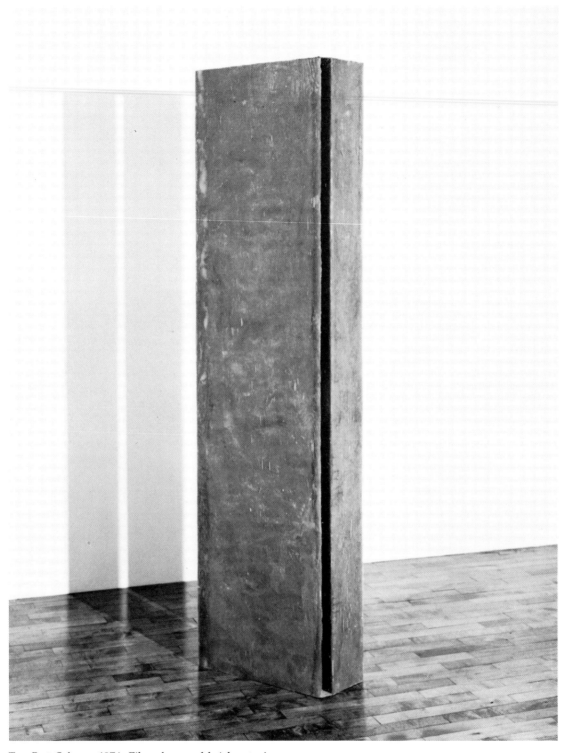

Two Part Column, 1974. Fiberglass and brick exterior
paint, 70½ x 7¼ x 17¾″ (179.1 x 18.4 x 45.6 cm).
Collection of Barbara Rose.

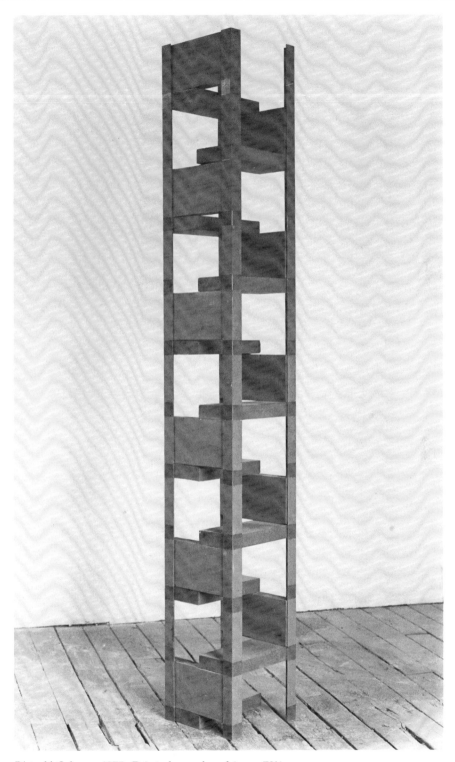

Rietveld Column, 1975. Painted wood and iron, 73¼ x
10½ x 10½ (186.1 x 26.7 x 26.7 cm). Collection of the
artist, courtesy Daniel Weinberg Gallery, San Francisco.

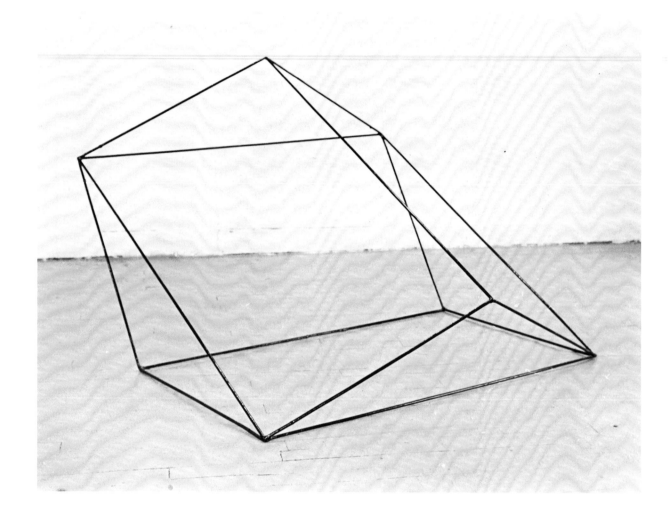

Architectural Object, 1978. Welded and painted steel
rods, 52 x 72 x 72″ (132.1 x 182.9 x 182.9 cm). Collection
of the artist, courtesy Daniel Weinberg Gallery,
San Francisco.

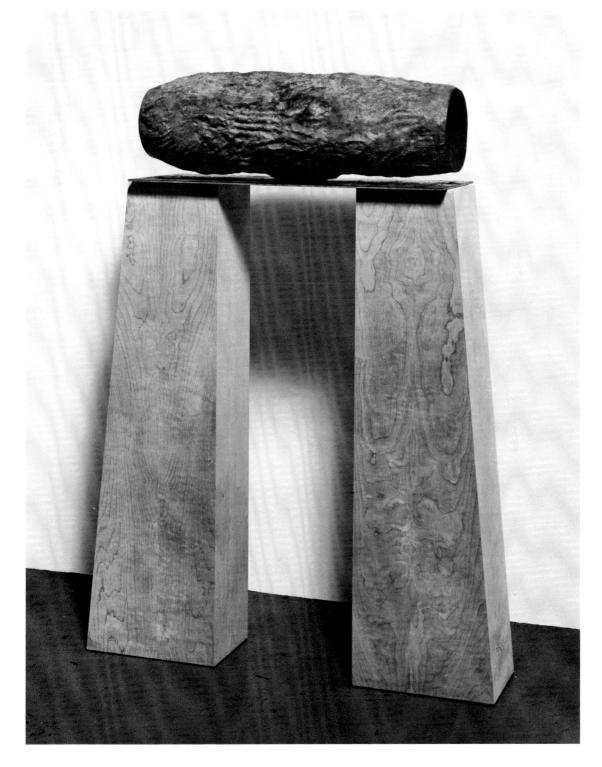

A1, 1981. Bronze, 12 x 35½ x 15″ (30.4 x 90.2 x 38.1 cm).
Margo Leavin Gallery, Los Angeles.

JOHN DUFF

Born in Lafayette, Indiana, 1943
Studied at the San Francisco Art Institute (B.F.A., 1967)
Lives in New York

SELECTED SOLO EXHIBITIONS

1967 Brady Gallery, San Francisco, "John Duff"

1970 David Whitney Gallery, New York, "John Duff"

1971 Galerie Ricke, Cologne, West Germany,
 "John Duff"
 David Whitney Gallery, New York, "John Duff"

1972 Irving Blum Gallery, Los Angeles, "John Duff"
 Janie C. Lee Gallery, Dallas, "John Duff"
 John Bernard Myers Gallery, New York,
 "Fiberglass Sculpture"

1973 John Bernard Myers Gallery, New York,
 "John Duff"

1974 Daniel Weinberg Gallery, San Francisco,
 "John Duff"

1975 Daniel Weinberg Gallery, San Francisco,
 "John Duff"
 Willard Gallery, New York, "John Duff"

1976 Willard Gallery, New York, "John Duff"

1977 Daniel Weinberg Gallery, San Francisco,
 "John Duff: Works from 1967–1977"

1978 623 Broadway, New York,
 "John Duff Sculpture: Large Scale Sculpture"
 Galerie Swart, Amsterdam, "Plastieken van
 Staafijzer"
 Willard Gallery, New York, "John Duff
 Sculpture: Small Scale Sculpture"

1979 Art Gallery, California State University,
 Sonoma, "John Duff Sculpture Retrospective,
 1967–1979." Exhibition catalogue, text by
 Robert McDonald

1980 Daniel Weinberg Gallery, San Francisco,
 "John Duff"

1981 Margo Leavin Gallery, Los Angeles,
 "John Duff: Bronze Sculpture"

SELECTED GROUP EXHIBITIONS

1969 Whitney Museum of American Art, New York,
 "Anti-Illusion: Procedures/Materials."
 Exhibition catalogue, texts by Marcia Tucker
 and James Monte

1970 Galerie Ricke, Cologne, West Germany,
 "Programm III: Bilder Skulpturen, Objekte
 Zeichnungen"
 Whitney Museum of American Art, New York,
 "1970 Annual Exhibition: Contemporary
 American Sculpture." Exhibition catalogue

1973 La Jolla Museum of Contemporary Art,
 California, "The Wall Object"
 Whitney Museum of American Art, New York,
 "1973 Biennial Exhibition: Contemporary
 American Art." Exhibition catalogue

1975 The Museum of Modern Art, New York,
 "76 Jefferson"
 Willard Gallery, New York,
 "Group Show: Drawings"

1976 Willard Gallery, New York, "Selections"

1977 The Solomon R. Guggenheim Museum, New
 York, "Nine Artists: Theodoron Awards."
 Exhibition catalogue, text by Linda Shearer
 New York State Museum, Albany,
 "New York: The State of Art"

1978 Holly Solomon Gallery, New York, "Gold/Silver"
 Daniel Weinberg Gallery, San Francisco,
 "Up Against the Wall"
 Whitney Museum of American Art, New York,
 "American Art, 1950 to the Present"
 Exhibition brochure, text by Patterson Sims
 Willard Gallery, New York, "Group Show"

1979 The Museum of Modern Art, New York,
 "Contemporary Sculpture: Selections from the

Collection of The Museum of Modern Art."
Exhibition catalogue, text by Kynaston
McShine
Whitney Museum of American Art, New York,
"The Decade in Review: Selections from the
1970s." Exhibition brochure, text by Patterson
Sims

1980 Norton Gallery of Art, West Palm Beach,
Florida, "Material Matters: Seven Young
Contemporary Artists" (traveled to Spoleto
Festival, Charleston, South Carolina, and The
Clocktower, Institute for Art and Urban
Resources, New York). Exhibition catalogue,
text by Edward Albee
Stamford Museum and Nature Center,
Connecticut, "Concrete Proposals: Seven
Young Contemporary Artists." Exhibition
catalogue, text by Edward Albee

1981 American Academy and Institute of Arts and
Letters, New York, "Exhibition of Work by
Newly Elected Members and Recipients of
Honors and Awards." Exhibition brochure
The Grey Art Gallery and Study Center, New
York University, "Tracking the Marvelous."
Exhibition catalogue, text by John Bernard
Myers

SELECTED ARTICLES AND REVIEWS

Kasha Linville, "New York," *Artforum,*
9 (November 1970), pp.85–86.

Carter Ratcliff, "New York Letter," *Art International,*
15 (December 1971), p.60.

Barbara Rose, "Where We Are and What We Like,"
New York, April 3, 1972, p.62.

Lenore Goldberg, "Contemporary Aspects of
Primitivism," *Arts Magazine,* 47 (May 1973),
pp.61–62.

James Collins, "Reviews," *Artforum,* 11 (June 1973),
p.93.

Phyllis Derfner, "New York," *Art International,*
19 (May 1975), p.67.

Judith Tannenbaum, "Arts Reviews," *Arts Magazine,*
49 (June 1975), p.16.

Roberta Smith, "Reviews," *Artforum,* 13 (Summer 1975),
p.74.

Denise Bratton, "John Duff," *Arts Magazine,*
50 (March 1976), p.6.

Thomas B. Hess, "Dumb Is Beautiful," *New York,*
March 3, 1976, p.88.

Peter Frank, "Reviews," *Art News,* 76 (May 1976),
p.134.

Susan Howe, "John Duff at Willard," *Art in America,* 64
(September 1976), p.111.

Willy Eisenhart, "John Duff," *Arts Magazine,*
51 (March 1977), p.10.

Gerrit Henry, "Reviews," *Art News,* 76 (April 1977),
p.131.

Judith Tannenbaum, "Arts Reviews," *Arts Magazine,* 51
(April 1977), p.31.

Eric Gibson, "New York," *Art International,*
22 (February 1979), pp.27–28.

Suzaan Boettger, "Admitting Sensuality," *Artweek,*
November 10, 1979, p.4.

William Zimmer, "Spirit in the Sky,"
SoHo Weekly News, June 4, 1980, p.26.

ALAN SARET: WORKS IN THE EXHIBITION

Red and Green Flat Spiral Hexarectathax, 1967–76
Painted wire mesh, 49 x 42 x 66" (124.5 x 106.7 x 167.6 cm)
Charles Cowles Gallery, New York

True Jungle: Canopy Forest, 1968
Painted galvanized wire, 108 x 216 x 48"
(274.3 x 548.6 x 121.9 cm) variable
Whitney Museum of American Art, New York; Gift
of the Howard and Jean Lipman Foundation, Inc. 69.7

Green Wave of Air, 1968–69
Painted galvanized hexagonal wire netting,
54 x 60 x 48" (137.2 x 152.4 x 121.9 cm)
Daniel Weinberg Gallery, San Francisco, and Charles
Cowles Gallery, New York

Untitled (Folding Glade), 1969
Vinyl-coated hexagonal wire netting, 86¾ x 49 x 41⅝"
(220.4 x 124.5 x 105.7 cm)
The Museum of Modern Art, New York

Four Piece Folding Glade, 1970
Painted wire mesh, 144 x 60 x 36"
(265.8 x 152.4 x 91.4 cm) variable
Private collection

Annamalaxxy, 1980
Nickel wire, 28 x 60 x 23" (71.1 x 152.4 x 58.4 cm)
Charles Cowles Gallery, New York

Autumn Cumulus, 1980
Lacquered copper wire, 48 x 40 x 36"
(121.9 x 101.6 x 91.4 cm)
Charles Cowles Gallery, New York

Copper Connection, 1980
Copper wire, 132 x 132 x 48"
(335.3 x 335.3 x 121.9 cm) variable
Charles Cowles Gallery, New York

Mount of Varianath, 1980
Lacquered wire and copper wire, 72 x 48 x 54"
(182.9 x 121.9 x 137.2 cm) variable
Charles Cowles Gallery, New York

Red and Blue Infinity Cluster Cloud, 1980
Lacquered wire and kymar, 31 x 21 x 21"
(78.7 x 53.3 x 53.3 cm)
Private collection

Wave Hill, 1980
Stainless steel wire, 72 x 84 x 60"
(182.3 x 213.4 x 152.4 cm)
Charles Cowles Gallery, New York

Paracongregata, 1981
Nickel and galvanized wire, 33 x 72 x 50"
(83.8 x 182.9 x 127 cm)
Collection of Contemporary Arts Consortium

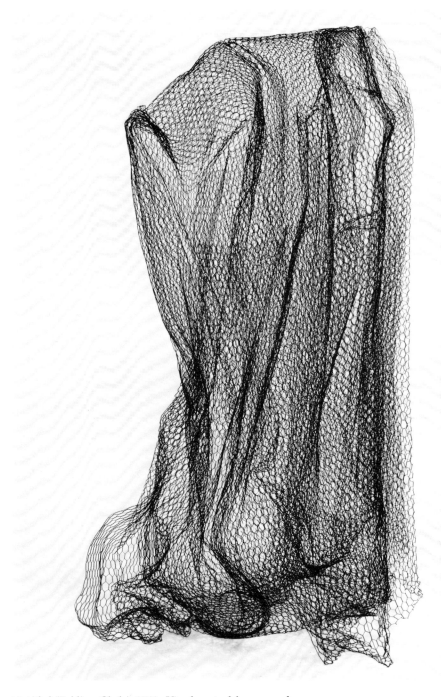

Untitled (Folding Glade), 1969. Vinyl-coated hexagonal
wire netting, 86¾ x 49 x 41⅝″ (220.4 x 124.5 x 105.7 cm).
The Museum of Modern Art, New York.

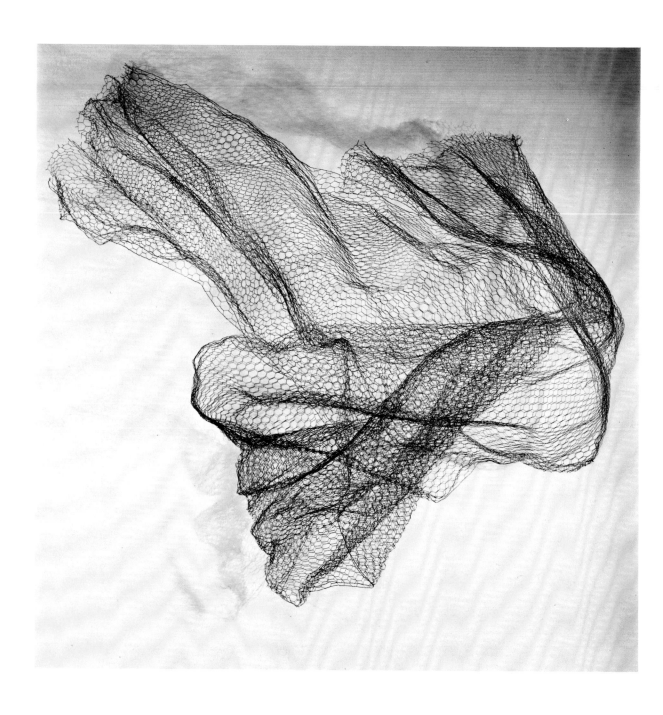

Green Wave of Air, 1968–69. Painted galvanized
hexagonal wire netting, 54 x 60 x 48" (137.2 x 152.4 x
121.9 cm). Daniel Weinberg Gallery, San Francisco, and
Charles Cowles Gallery, New York.

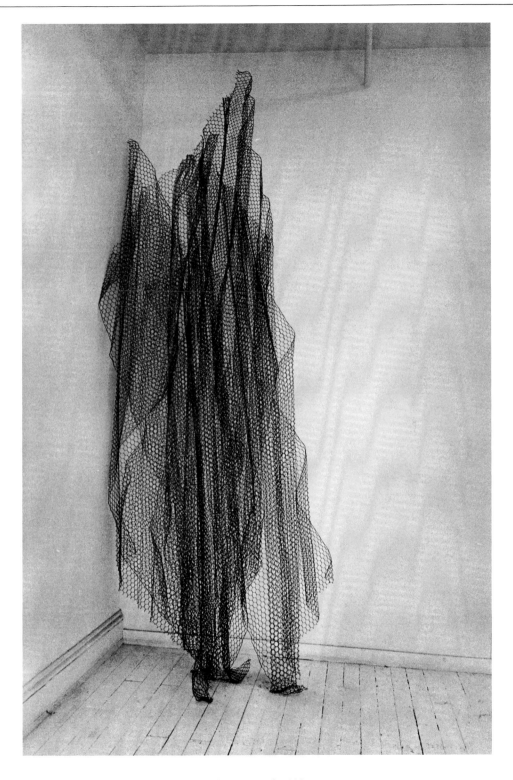

Four Piece Folding Glade, 1970. Painted wire mesh, 144 x
60 x 36″ (265.8 x 152.4 x 91.4 cm) variable. Private collection.

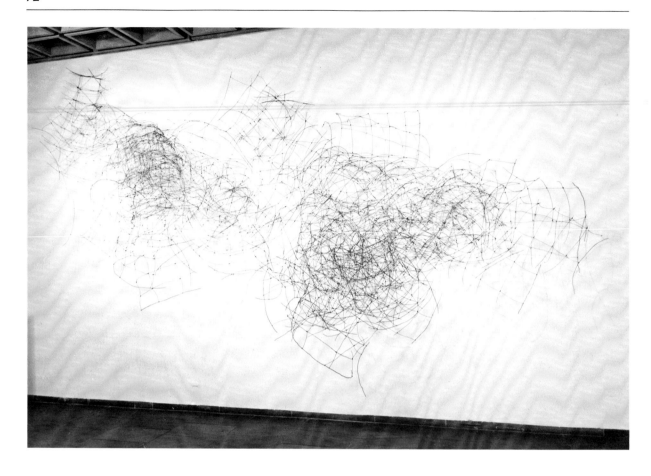

True Jungle: Canopy Forest, 1968. Painted galvanized
wire, 108 x 216 x 48" (274.3 x 548.6 x 121.9 cm) variable.
Whitney Museum of American Art, New York; Gift of
the Howard and Jean Lipman Foundation, Inc. 69.7

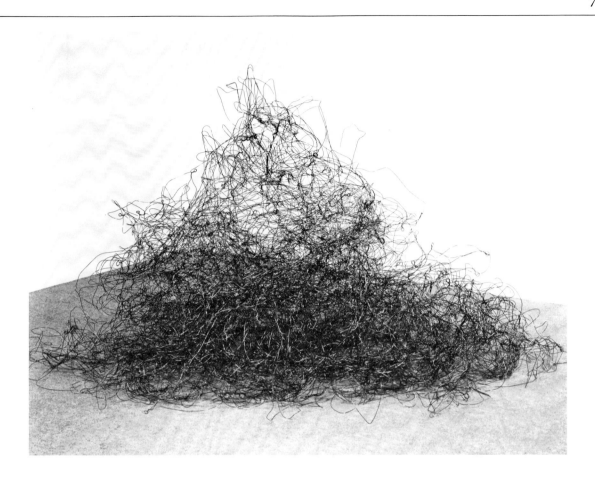

Autumn Cumulus, 1980. Lacquered copper wire, 48 x 40
x 36″ (121.9 x 101.6 x 91.4 cm). Charles Cowles Gallery,
New York.

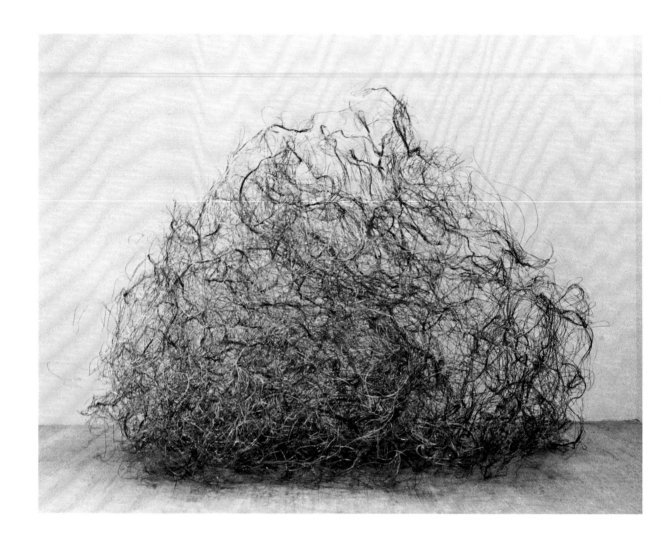

Wave Hill, 1980. Stainless steel wire, 72 x 84 x 60″
(182.3 x 213.4 x 152.4 cm). Charles Cowles Gallery,
New York.

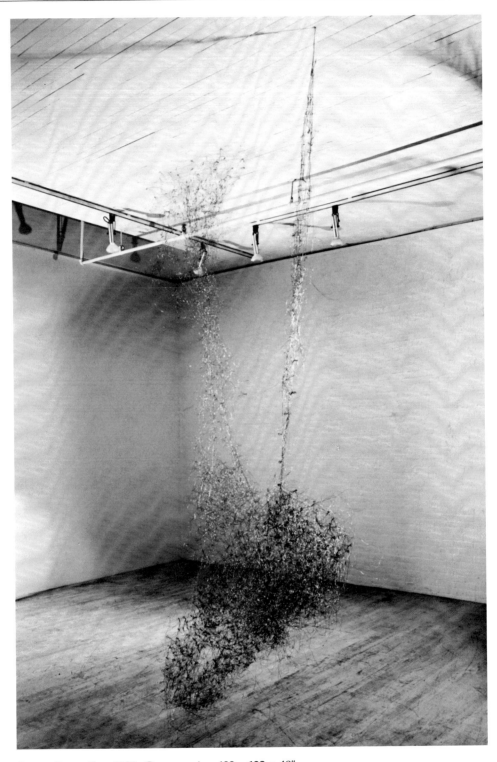

Copper Connection, 1980. Copper wire, 132 x 132 x 48″
(335.3 x 335.3 x 121.9 cm) variable. Charles Cowles
Gallery, New York.

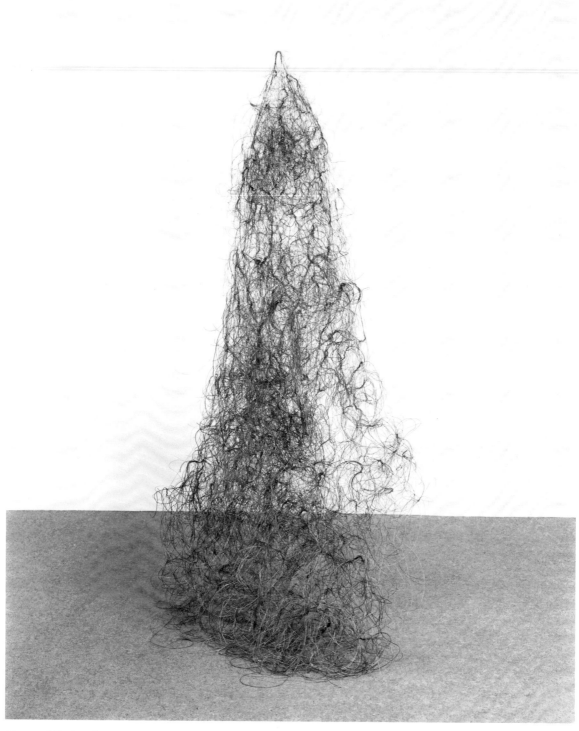

Mount of Varianath, 1980. Lacquered wire and copper
wire, 72 x 48 x 54 (182.9 x 121.9 x 137.2 cm) variable.
Charles Cowles Gallery, New York.

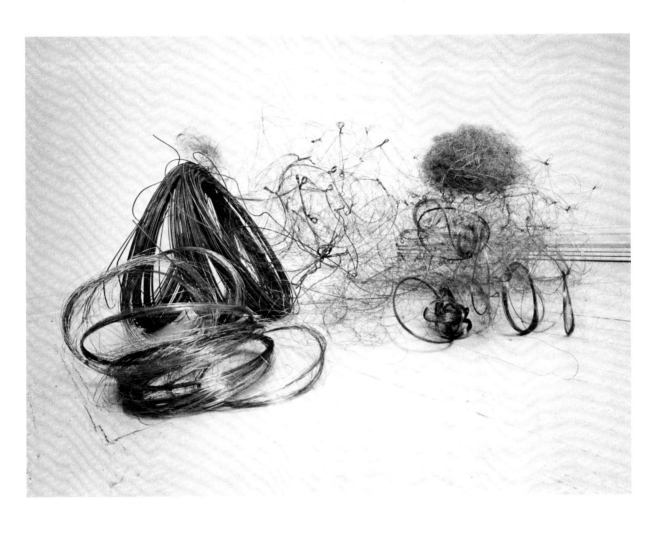

Paracongregata, 1981. Nickel and galvanized wire, 33 x
72 x 50″ (83.8 x 182.9 x 127 cm). Collection of
Contemporary Arts Consortium.

ALAN SARET

Born in New York, 1944
Studied at Cornell University, Ithaca, New York
 (B. A., 1966); Hunter College, New York (1966–68)
Lives in Harrison, Arkansas

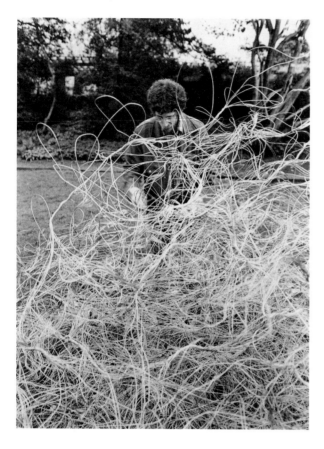

SELECTED SOLO EXHIBITIONS

1968 Bykert Gallery, New York, "Mountains of
 Chance, Documents of Ruralism"

1970 Bykert Gallery, New York, "Pictures"
 Spring Palace, New York, "Alan Saret Sculptures"

1974 The Clocktower, Institute for Art and Urban
 Resources, New York, "Drawings, Watercolors
 and Sculpture"

1977 Seattle Art Museum, Modern Art Pavilion,
 "Mesh Work Architecture and Dragon's Tooth
 Castings"

1978 Fine Arts Gallery, University of California,
 Irvine, "Visionary Drawings, Energy Fields,
 Sculpture"

1979 University Art Museum, University of
 California, Berkeley, "Permutation Cluster
 Galaxy." Exhibition brochure, text by Michael
 Auping
 Daniel Weinberg Gallery, San Francisco,
 "Sculpture and Drawings"

1980 Charles Cowles Gallery, New York, "Alan Saret"

1981 Galerie Rudolf Zwirner, Cologne, West
 Germany, "Alan Saret: Skulpturen und
 Zeichnungen"

SELECTED GROUP EXHIBITIONS

1968 Allen Memorial Art Museum, Oberlin, Ohio,
 "Three Young Americans"
 Bykert Gallery, New York, "Group Show"
 Whitney Museum of American Art, New York,
 "1968 Annual Exhibition: Contemporary
 American Sculpture." Exhibition catalogue

1969 Castelli Warehouse, New York,
 "9 at Leo Castelli"
 Washington University Gallery of Art, Steinberg
 Hall, St. Louis, "Here and Now." Exhibition
 catalogue, text by David Sewell

1970 Sidney Janis Gallery, New York,
 "String and Rope." Exhibition catalogue

1971 Lalit Kala Akademi, New Delhi,
 "Second Triennale—India 1971." Exhibition
 catalogue, text by Mulk Raj Anand

1973 Whitney Museum of American Art, New York,
 "American Drawings, 1963–1973." Exhibition
 catalogue, text by Elke M. Solomon

1975 Artpark, Lewiston, New York, "Artpark 1975"
 (outdoor installation: *Ghosthouse*). Exhibition
 catalogue, text by David Katzive
 The Clocktower, Institute for Art and Urban
 Resources, New York, "Selections from the
 Collection of Herbert and Dorothy Vogel"
 (traveled to Institute of Contemporary Art of
 The University of Pennsylvania, Philadelphia,
 and Contemporary Arts Center, Cincinnati).
 Exhibition catalogue, text by Suzanne
 Delehanty
 Whitney Museum of American Art, New York,
 Downtown Branch, "Materials and
 Manipulations." Exhibition brochure

1976 Akademie der Künste, West Berlin,
 "New York—Downtown Manhattan: SoHo"
 (traveled to Louisiana Museum, Humlebaek,
 Denmark). Exhibition catalogue, texts by
 Werner Duttman and Lucy R. Lippard

P.S.1, Institute for Art and Urban Resources, Long Island City, New York, "Rooms P.S.1." Exhibition catalogue, text by Alanna Heiss

1977 Georgia Museum of Art, University of Georgia, Athens, "Open to New Ideas"
Institut d'Art Contemporain de Montréal, "03 23 03" (traveled to The National Gallery of Canada, Ottawa)
The Museum of Modern Art, New York, "American Drawn and Matched." Exhibition catalogue
The University of Michigan Museum of Art, Ann Arbor, "Works from the Collection of Dorothy and Herbert Vogel." Exhibition catalogue, text by Bret Waller
Whitney Museum of American Art, New York, "1977 Biennial Exhibition." Exhibition catalogue

1978 Institute of Contemporary Art of The University of Pennsylvania, Philadelphia, "Dwellings" (traveled to Neuberger Museum, State University of New York, College at Purchase). Exhibition catalogue, text by Lucy R. Lippard
Herbert F. Johnson Museum of Art, Cornell University, Ithaca, New York, "Cornell Then, Sculpture Now." Exhibition catalogue, text by Robert Carleton Hobbs
Daniel Weinberg Gallery, San Francisco, "Up Against the Wall"

1979 Artists Space, New York, "Artists Draw." Exhibition catalogue, text by Donald Sultan
The Museum of Modern Art, New York, "Contemporary Sculpture: Selections from the Collection of The Museum of Modern Art." Exhibition catalogue, text by Kynaston McShine

1980 American Pavilion, 39th Venice Biennale, "Drawings: The Pluralist Decade." Exhibition catalogue, text by Janet Kardon
Aspen Center for the Visual Arts, Colorado, "Beyond Object"
Max Hutchinson Gallery, New York, "10 Abstract Sculptures American and European, 1940–1980." Exhibition catalogue.
Institute of Contemporary Art, Boston, "Drawings/Structures"
Los Angeles Institute of Contemporary Art, "Architectural Sculpture." Exhibition catalogue, texts by Debra Burchett, Susan C. Larsen, Lucy R. Lippard, and Melinda Wortz
Wave Hill, Bronx, New York, "Temporal Structures." Exhibition catalogue, text by Kay Larson

1981 William Paterson College Gallery, Wayne, New Jersey, "112 Greene Street Revival"

Selected Articles and Reviews

Ellen H. Johnson and Athena T. Spear, "Three Young Americans: Krueger, Nauman, Saret," *Allen Memorial Art Museum Bulletin,* 25 (Spring 1968), pp.93–101.

Philip Leider, "The Properties of Materials: In the Shadow of Robert Morris," *New York Times,* December 22, 1968, p.31.

Emily Wasserman, "New York," *Artforum,* 7 (January 1969), p.59.

Hilton Kramer, "The Emperor's New Bikini," *Art in America,* 57 (January/February 1969), p.54.

Max Kozloff, "9 in a Warehouse: An Attack on the Status of the Object," *Artforum,* 7 (February 1969), pp.38–42.

Clement Meadmore, "Thoughts on Earthworks, Random Distribution, Softness, Horizontality and Gravity," *Arts Magazine,* 43 (February 1969), pp.26–28.

Emily Wasserman, "Alan Saret's Studio Exhibition," *Artforum,* 8 (March 1970), pp.62–66.

"Alan Saret: A Synthesis" (drawings), *Artforum,* 8 (May 1970), pp.48–53.

Douglas Davis, "Country Art and City Art," *Newsweek,* March 11, 1974, p.90.

Willoughby Sharp, "Alan Saret: Installation for Man," *Avalanche,* Summer 1975, pp.7–11.

Alan Saret, "The Ghosthouse of ALAEL at Artpark," *Art-Rite,* nos. 11/12 (Winter/Spring 1975/76), pp.32–39.

Jonathan Crary, "Alan Saret," *Arts Magazine,* 52 (September 1977), p.4.

Suzaan Boettger, "Alan Saret—Visionary Aspirations," *Artweek,* March 17, 1979, p.7.

Richard Armstrong, "Reviews: Alan Saret, Daniel Weinberg Gallery," *Artforum,* 18 (February 1980), pp.106–7.

Kay Larson, "Review," *The Village Voice,* May 26, 1980, p.78.

William Zimmer, "Reviews," *SoHo Weekly News,* May 28, 1980, p.53.

Philip Yenawine, "Beyond Object at the Aspen Center for the Visual Arts," *Artspace,* 4 (Summer 1980), pp.14–17.

Paul Stimson, "Review of Exhibitions," *Art in America,* 68 (September 1980), pp.121–22.

Photograph Credits

Photographs of the works of art reproduced have been supplied, in many cases, by the owners or custodians of the works, as cited in the captions. The following list applies to photographs for which an additional acknowledgment is due.

Jon Abbott, pp. 73, 76; Courtesy Scott Burton, p. 40; Edward Claycomb, p. 74; Geoffrey Clements, pp. 19, 23, 24, 26, 62, 72; Courtesy Paula Cooper Gallery, New York, cover (Benglis); Bevan Davies, pp. 45, 47, 49, 50, 51, 52; D. James Dee, p. 53, cover (Dennis); eeva-inkeri, p. 70; Roy M. Elkind, p. 37; Roger Gass, p. 38; © Gianfranco Gorgoni, pp. 71, 77; Leslie Harris, p. 41; © Marbeth, p. 78; Robert E. Mates and Mary Donolon, p. 61 left; Robert E. Mates and Paul Katz, p. 46; Douglas M. Parker, p. 65; Courtesy Max Protetch Gallery, New York, pp. 33, 34, 39; William Quinn, pp. 29, 42, 54, 66; Nathan Rabin, p. 21; Abby Robinson, p. 36; Kunie Sugiura, pp. 57, 58, 59, 60, 63, 64; Frank J. Thomas, p. 25; Jerry L. Thompson, p. 35, cover (Duff); Courtesy Willard Gallery, New York, p. 61 right.

Designed by Bruce Campbell
Typeset by Elizabeth Typesetting Company
Printed by William J. Mack Company

This book was published in conjunction with an exhibition at the Whitney Museum of American Art, July 22–September 27, 1981.
The publication was organized at the Whitney Museum by Doris Palca, *Head, Publications and Sales,* Sheila Schwartz, *Editor,* James Leggio, *Copy Editor,* and Susan Ebersole, *Assistant.*

Artists' bibliographies and exhibition lists were compiled by William Quinn.